Women
Photograph
Men

Women Photograph Men

EDITED BY

Dannielle B. Hayes

INTRODUCTION BY Molly Haskell

WILLIAM MORROW and COMPANY, INC. ———— New York

Library of Congress Cataloging in Publication Data
Main entry under title:

Women photograph men.

 1. Men—Portraits. 2. Women photographers.
I. Hayes, Dannielle B.
TR681.M4W64 779′.23′092 2 77-6905
ISBN 0-688-03214-1
ISBN 0-688-08214-9 pbk.

Book design by Madelaine Caldiero and Kathy Peck

In memory of Diane Arbus,
photographer and friend,
who dared to see reality

This book was created with the hearts and eyes of many people. I would especially like to thank Frances McLaughlin-Gill for her enthusiastic support as assistant editor; Pamela Hatch for her encouragement and her trust in first instincts; and my husband, Merle, and my daughter, Amie, for their patience with my ''philanthropic activities.''

My gratitude is extended as well to the International Women's Arts Festival, the coordinators of ''Breadth of Vision,'' my assistants in ''Woman Photographs Man,'' the International Center of Photography, and Morgan Press.

Most of all, I am indebted to the many women photographers who shared their visions with me, and the men revealed in those visions.

Foreword by DANNIELLE B. HAYES

Men as a focus of attention for women photographers is hardly unique. Women have been behind cameras capturing the male image since the beginnings of photography. Gertrude Käsebier, one of America's earliest female photographers, is noted for her pictures of women and children, but many of her photographs of men, particularly American Indians, are among her most powerful works. Imogen Cunningham, another remarkable photographer, inadvertently became a pioneer in the male nude debate. When she had nude photographs of her husband published in the Seattle *Town Crier* in 1915, they created such a scandal that she was virtually forced to hide the negatives for more than fifty years. With a more daring renown, the late Diane Arbus penetrated the male image by photographing men in nudist colonies, and men appearing to be women.

However, in the early seventies, increased social awareness, inspired by the feminist movement, provided encouragement for many women to examine themselves and their condition with a fresh eye. Inevitably, the camera became an astoundingly useful tool in this search. When women photographers, often with children strapped to their backs, turned the camera on themselves and other women, it revealed passions a far cry from the glossy images seen on most newsstands. The women discovered that the camera, in its innate honesty, was liberating rather than confining. In the hands of some, the camera was revelationary. As photographs were compared, exhibits hung, and books published, women, through the art of photography, were gradually able to

perceive themselves more clearly—some for the first time.

By exploring the after-images of female sexuality, emotions, and stereotyped roles within our society, it soon became evident that women were not the only victims. Men, too, were stifled by the demands of society's expected roles. The natural extension of this realization, of course, was to try to define men as they really were—not as women expected them to be or as men expected themselves to be. If women photographers together focused on the images of men, then they might touch the souls of this other reality. The resulting photographs in *Women Photograph Men* are forceful statements toward that definition.

Women Photograph Men was originally conceived and seen as an outdoor slide/sound presentation entitled "Woman Photographs Man" in Rockefeller Center on May 2, 1976. The day-long affair under the aegis of the International Women's Arts Festival presented women's work in crafts, dance, fine art, literature, and music as well as in photography. Due to limitations of space and time, the photographs were projected through a screen from the back of a truck. The show was so successful that we entertained the hope that somehow it would have a life beyond that one-day exposure. Two weeks later when those photographs were projected onto a wall at William Morrow and Company, publishers, they began another life in this book. The ambiguous "man" was changed to the more definitive "men," and *Women Photograph Men* was born.

The photographers represented in this book

come from a wide range of life-styles and pho-
tographic experiences. Many of them were
represented in the largest exhibition of work
by women photographers, "Breadth of Vision:
Portfolios of Women Photographers," an ex-
hibit celebrating the UN-sponsored Interna-
tional Women's Year. More than four hundred
works by one hundred and ten photographers
from all over the United States and Canada
were mounted in the galleries of the Fashion
Institute of Technology from September 18 to
October 15, 1975. The exhibition received min-
imal coverage from the press, so a small group
of photographers from "Breadth of Vision"
continued to meet over the winter months to
explore further avenues for focusing attention
on the work of women photographers. The idea
for the "Woman Photographs Man" slide pres-
entation grew out of one of these meetings
and all the participants from "Breadth of
Vision" were invited to submit photographs for
the slide show. Later, when the show was con-
sidered for book publication, this same group
was again invited to participate. In addition,
the book was opened up to numerous photog-
raphers whose work had come to my attention.

The editing task for *Women Photograph
Men* was complex. It became clear early on
that the photographs could be divided into
extremely general categories such as little
boys, old men, fathers, nudes, men alone, and
a large collection, which at the risk of offend-
ing precise art historians, was termed "sur-
realist." Not only were these categories often
ambiguous, but in the subsequent editing ses-
sions—and there were many—the categories
fell apart almost completely. This system was
used merely as a point of departure.

The final selection was made primarily on
the basis of communicative insight and artistic
merit. Also, close attention was paid to subject
matter appearing most frequently, for I felt
that by their sheer numbers, these subjects
were of great importance to women. I tried to
reproduce a balance of these factors in the
book itself. Over one thousand photographs
were submitted, and since only a small per-
centage of these could appear in the final book,
there were many that had to be omitted with
genuine regret.

Editing this book was an enriching experi-
ence for me both as a photographer and as a
woman. As a photographer, I was impressed
with the consistent high quality and the in-
triguing points of view of the work that was
submitted, both by older more experienced
photographers, and often by very young pho-
tographers. Photographs are frames within
time and space; surrounding events and pas-
sions involved are mere projections, sometimes
suspended within the frame. The most provoc-
ative photographs are those which touch upon,
in some allusive way, a portion of those sus-
pended feelings. Getting hold of these feelings
can be risky; a great threat to the one being
photographed, and a responsibility for the
photographer. This quality can become intensi-
fied when a woman photographer attempts to
capture the image of a man. Sharing these
moments of vision with other women photog-
raphers has been reward in itself.

As a woman, I was moved by the profound
compassion and understanding expressed in
these photographs. For a woman to see through
the guises of a man—his loneliness, his pride,
his nakedness all too often concealed by his
own prudence—is to uncover his true identity.
What emerges is the realization that men are
undeniably a contradiction of expressions,
alive and changing. In other words, when the
guises are stripped away, men and women, at
a level of feeling, are very much a reflection of
each other. It is my hope that these photo-
graphs, as a visual statement, will be inspiration
toward achieving a more universal harmony
between men and women.

Introduction by MOLLY HASKELL

A: Women are like men. B: Women are unlike men. A: There is no such thing as a "woman's sensibility." B: There is such a thing as a "woman's sensibility." Under these opposing banners mighty pens have clashed since the early days of the women's movement. Both are true, of course; it is the opposition that is false. Not only that, it is damaging because it obscures yet a third reality: that women are unlike one another. It is this truth that becomes paramount as more and more women enter the arts and professions and cross over the sexual divide, defying the limits of a "female" destiny and contravening its laws. In a world divided into male and female preserves, it has, in any case, most often been the trespassers—the spiritual androgynes—who have made cultural history.

Still, I see no reason why we shouldn't pursue intimations of a feminine—what? not destiny but, say, point of departure—along lines suggested by formulations "B," as long as we tread gingerly, aware that for every generalization there are countless exceptions, and that our conjectures not only are not binding, but are perhaps passing into history even as we write them. The inquiry into whatever it is that constitutes a "woman's point of view," had best be made cautiously and with indirection—in other words, in precisely the spirit in which the photographs of this book have been taken and assembled.

The fact that a book called *Women Photograph Men* would not have been published ten years ago, and will no longer—with any luck—be thinkable ten years hence, does not make it

a perishable "fad" item. On the contrary, it becomes all the more valuable as an act of cultural reclamation, a microscopic enlargement of sexual crosscurrents in one area of the human map. If to our brave new unisex progeny of the twenty-first century, the dating and mating rituals, the romantic agonies and the double standard of our own appear as remote as the practices of one of Margaret Mead's Samoan tribes appear to us, then all the more reason to try and fathom—and control—the swirling currents of our sexual evolution before they overwhelm us.

All right, the skeptic in me interposes. Let us ask one question: If these photographs were in the company of photographs by men, neither group identified as such, would we guess the sex of the photographers with any accuracy? Quite possibly not, but that doesn't make the inquiry invalid. A film critic may not be able to recognize the hand of a director from one frame of his film; a literary critic may fail to guess the identity of a favorite poet from an unfamiliar line. But that doesn't disprove their insights into the artist's work. A psychiatric patient may think to trick his doctor by recounting a factitious dream, but the doctor's acceptance of that dream in no way discredits him as an analyst. We must proceed on the assumption of a certain good faith. We are entitled to note, in the cumulative effect of these photographs by women, certain recurring themes: a wry, off side view of the men under consideration; a sensitivity to the privileged moment; a tendency toward a novelistic rather than dramatic organization of material;

and, most prominently, a certain diffidence, a refusal to make too grand or final a claim about the nature of man through any one photograph.

It is the nature of the anthology or group show to subordinate the identifying marks of the individual artist to the collective aesthetic —whether it be early twentieth-century Irish playwrights or West Coast artists . . . or women. Here the bracket is sexual and the links we are encouraged to pursue make no allowance for differences in quality and kind of the works, which—one assumes—were not even taken with the theme in mind. And yet, universals begin to rise to the surface like bubbles in water, signs of a shared ground, images which give rise to impressions which turn into words to describe an intellectual and emotional experience common to women. They are there, and why not? The analyst who has been presented with the false dream may be led to a dazzling insight into his patient, for the unconscious of his patient has spoken, after all, in the fabricating and/or selecting of the dream, in the way he places one word after another, an emphasis here, an omission there.

The adventure of critical analysis begins, like any laboratory experiment, with a working hypothesis, an artificial arrangement of the material so that constants and variables may emerge. The ethical and aesthetic standards by which we think and make our judgments, all of our judgments, in any given period are just such an arbitrary arrangement, but because we make them reflexively, like breathing, we don't perceive the impermanence of our frame of reference. The canons are implicit. Here, we acknowledge them. We apply the word "woman" to see what it will tell us.

First, from the very notion of such a collection, the idea that there is a fine irony at work suggests itself. We assume a sexual reversal, a turning of the tables. Will women who have for so long served as models for painters and photographers turn the lens on their artist worshipper-oppressors? Will their approach

stand on its head the historical sexist (and Capitalist) phenomenon described by the British Marxist art historian John Berger, in which the nude in European oil painting, far from being even a facsimile of a "real woman," was an instrument to satisfy the power and proprietary fantasies of a male consumer elite? Her nudity, as Berger analyzes it, had nothing to do with nakedness or with her own sexuality, but actually robbed her of her own inner life and intentionality, as she was posed not to act or interact within the painting, but to address herself directly to the desires of the male spectator.

And yet no such ironic reversal materializes, and there is nothing in the book to suggest an act of either emotional or ideological revenge. In fact, so far are they from any such polemical motives that the photographers here are defined almost negatively, by the ways in which they resist the impulse to generalize, and refuse—or are unable—to see men as men have seen women. Remember that the verb "to see" itself contains a fascinating polarity, meaning, at one end, an act of rational understanding, and at the other, a state of intuitive sympathy.

The historical difference between men and women, the one that makes possible a book such as this one, is crucial: men have approached the world as if it were theirs—to photograph, to apprehend, to understand and define, and women have not. Women, figuratively if not literally on the other side of the lens, have contented themselves with being figures in that landscape owned and surveyed by men. Within it, they have been proud and powerful, and they have been stunning and sublime. They have brought men to their heels —but according to a code of selective vassalage in which men were the philosopher/philanderers.

What is a woman? What does a woman want? This is a question automatically asked by the surveyor of the surveyed.

By contrast, what woman would dare ask

the converse—What is a man? What does a man want?—as if *his* position on earth were the shaky one, and as if in solving the riddle of one man she might unlock the mystery of them all. What woman would presume to paint or photograph a man as if she were asking that question, let alone answering it?

To the extent that they have been concerned with woman at all, artists through the ages have been slyly suggesting that they have penetrated woman's mystery. One doesn't have to subscribe entirely to Berger's theory to feel that in allowing herself to be portrayed as the Eternal Feminine, woman has yielded up her mortal soul, her changing, aging, arguing, idiosyncratic self. Because of the narcissism that is almost an inevitable stage (and sometimes the conclusion of her evolution), woman is a natural poser. In some portraits we feel that women have been waiting all their lives to be captured thus.

How very different is the impression of men —*men* as opposed to man—given us by these women. From the famous to the unknown, from the abstract to the quirkily human, we have men in the dazzling plural. Not only does none of them represent mankind, but those whose professions we recognize—Richard Burton and Moses Gunn, Baryshnikov and Nureyev, Billy Graham and Jimmy Carter, rugby players and soldiers, cyclists and cowboys—are seen more as individuals than as representatives of their professions.

For example, on facing plates (PLATES 20 and 21) we see two weatherbeaten faces, men so unlike in dress, coloring, bone structure and facial characteristics they might be from different planets. Yet we learn from the caption they are both cowboys, and both from Campo de Gato, Bahia. In presenting us with these two distinct images, not only is our need for *National Geographic* stereotypes confounded, but we are left with the challenging thought that where there are two, there are possibly three or four or more. What *is* a Bahia cowboy? The secret remains with him. Or rather, with *them*.

Actors, dancers, public figures, athletes, we see them not at the quintessential moment or in the prototypical pose, but off to one side, in the prologue, the intermission, the aftermath; in repose rather than in action; or—as with many of the sports photographs, we see the human being isolated from his activity, his positioning in the frame accentuating the space he hasn't yet mastered. Burton (PLATE 12), lost in thought, is sitting in the wings in rumpled clothes, possibly a costume, but what on stage would be a suit of armor, a disguise, here accentuates the lonely vulnerability of the man. Rugby players, grubby and mudspattered, leap in triumph after the game; basketball players' arms form an arc reminiscent of the silhouette-monster we used to make in childhood.

In portraits, time has been arrested, but only for a moment. Sensuality is immediate, cells are decaying almost before our eyes. There is a sense of time extending into the past and the future, of men resisting stasis and moving toward the action that will justify mortality. We see men not necessarily as they would like to be remembered, or as they see themselves, but in the ways women like to think of them— mortal, vulnerable, tender. Doing ''female'' things—carrying flowers, playing with their children. And they are playful too, comical in ways not often attributed to the ''humorless'' sex. Two of my favorites are the photographs of men with animals, respectively a man with cat (PLATE 42) and an elegant man turning away from a terrier (PLATE 43). The uncanny identification of man and beast carries with it in each picture (and they reinforce each other) a feeling at once comical and wondrous of connection between God's creatures.

Sometimes we are not immediately aware why a particular photograph has been taken. It is without the sharply defining moment, the arresting expression, the journalistic angle, some piece of contextual information or a familiarity with the photographer's *oeuvre* that might explain it. And yet, more often than not,

as we study the photograph we seem to be drawn by a train of feeling into its spirit, to understand intuitively what drew the photographer to the subject—and the subject to the photographer.

There is a chemistry, an unstated affinity, that binds the two together, and in many of the photographs there is an intimacy, an almost domestic warmth that envelops subjects both known and unknown—lovers, little boys, old men and strangers. (The photographs of families, of fathers and sons, are in many ways the least interesting because they are self-consciously, and sentimentally, feminine. There is a redundancy of "maternal" feeling.)

If we are at first unsure of the "point" of a photograph, it is because the photographer rejects the focal manipulation to which we are accustomed and revels in the novelistic immersion in life I noted earlier. If women photographers decline to ask the ultimate question, it is not that they are incurious. Rather, they ask many questions, and they elicit a complex of responses.

For reasons that may have as much to do with the relative accessibility of its technology as with their own mental equipment, women have made up a significantly larger portion of the world's great photographers than of its musicians or film directors or painters. Have they not been conditioned by the social necessity of being at once alert and self-effacing to develop that special quality of muted observation? Women are able to establish rapport with their subjects for what we now think of as "good" and "bad" reasons that are maddeningly intertwined. Because women have not been taken seriously (by men) as sexual competitors, they are less threatening, their presence less disturbing to a male ego. Perhaps this is why women can win the confidence of a small boy or a proud native, as her "imperialistic" male counterpart cannot.

Another element in that lack of manipulation, the antidramatic side of the woman's aesthetic, is the utter matter-of-factness with which she views the world, accepting its blemishes and deformities without blinking an eye. It is only after studying a photograph of a Vietnamese boy, or a man facing a pool with his back to us that we realize that one is an amputee and the other in a wheelchair. The defect is exploited neither for propaganda purposes nor for its power to suggest the artist's own sensitivity. (Similarly, in Diane Arbus' photographs we come through deformity and out the other side.)

The attitude behind most of the photographs is neither satirical nor consciously antiheroic, and yet because male rituals are not viewed with reverence or transforming belief, they inevitably reveal their own absurdity. We are suddenly aware that a great deal of romanticizing, mythologizing art is necessary to support the heroic tradition. (The monumental male-worshipping photographs of Leni Riefenstahl—not included—are the exception that proves the rule. Her photographs of African tribesmen are of a piece with her Nazi films in celebrating a virility cult at the very moment when bravado is masking the slide into decadence.)

With the exception of a head shot of Billy Graham (PLATE 52), gleaming at the apertures as if he had been internally wired for electricity, few of the portraits are overtly satirical, and expressions more often convey doubt than certainty. A soldier (PLATE 26) is deeply dismayed by war. The emphasis is on the emotions in even so apparently physical a photograph as the one of two rotund men (PLATE 34), their tattooed arms locked in an Indian-wrestling match. In this and other group photographs, the sense of camaraderie overwhelms that of conflict.

And speaking of arms, how many hands there are! Hands in full-length portraits, drawing our attention away from the face; hands severed from bodies; hands and bodies severed from heads; always hands involuntarily expressing something that has eluded the mind's control, telling a story it doesn't want told.

There's the clothing salesman (PLATE 107),

head cropped, standing over a headless mannequin, hands resting on the mannequin's shoulders, one as eerily artificial as the other. Moses Gunn's gnarled, bombastic hands (PLATES 54, 55, 56) cover his face like tendrils. Harold Pinter's hands (PLATE 53) make a camera with which to mock the photographer, and reveal more in their plump, menacing sensuality than would his face. Indeed, between the hands and the face, often the man's only areas of exposed skin, it is the hands which have not learned to lie. (I was sufficiently struck by the preponderance of hands in this collection to check it out elsewhere, and I found that, indeed, women are to an extraordinary degree fascinated by hands.) Hands are the source and symbol of male power, but they may also be naked and vulnerable, doubly "exposed." The face is not only a mask, it is the stage of conflicting emotions. With someone we know, it may harbor thoughts that are directed against us, and with someone we love, it is too complex to provide a simple receptacle for our love. The mute and inglorious hands, however, unquestioning as pets and with a character all their own, we can love as surrogate for the man.

Finally, although knowing a photograph was made by a woman may not necessarily increase our appreciation, it may add a dimension or give it an emotional coloring it would not otherwise have. The marvelous shot of the Hasidim huddled under an umbrella (PLATE 91) seems imbued with an affection that might have shaded more into mockery had the photograph been taken by a man. And there are those in which the subjects respond directly to the sex of the photographer—such as the flirtatiously laughing Parisian soldiers (PLATE 30). To the extent that there is still sexual tension between men and women (or men and men, for that matter), this tension is bound to affect the charged, intimate space between photographer and subject. How exciting that this is so! And although—again—it may not be indispensable to our understanding of a photograph, the knowledge of whether a male nude was photographed by a man or by a woman will affect the degree of sexual ambiguity the photograph contains. (If the photographs of this book are any proof, women still can't be casual about the penis.)

And when we have said all of this, we have said nothing of the relative merits of the individual photographs, how many and which ones will be preserved, collected, pored over years from now. That remains the province of other anthologies and other critics, awaiting further explorations and cross-references of the photographers included here.

Nor have we said anything definitive about the nature of men and women, categories which have become mercilessly unreliable in recent years. But for those with a feeling for the nuances of our sexual heritage, this collection offers a confirmation of the continuing creative tension between men and women, and of women's amazing talent for capturing the warriors and the witnesses in moments of revelation before, during, and after the epic struggle.

Women
Photograph
Men

Untitled
Helena Chapellin Wilson

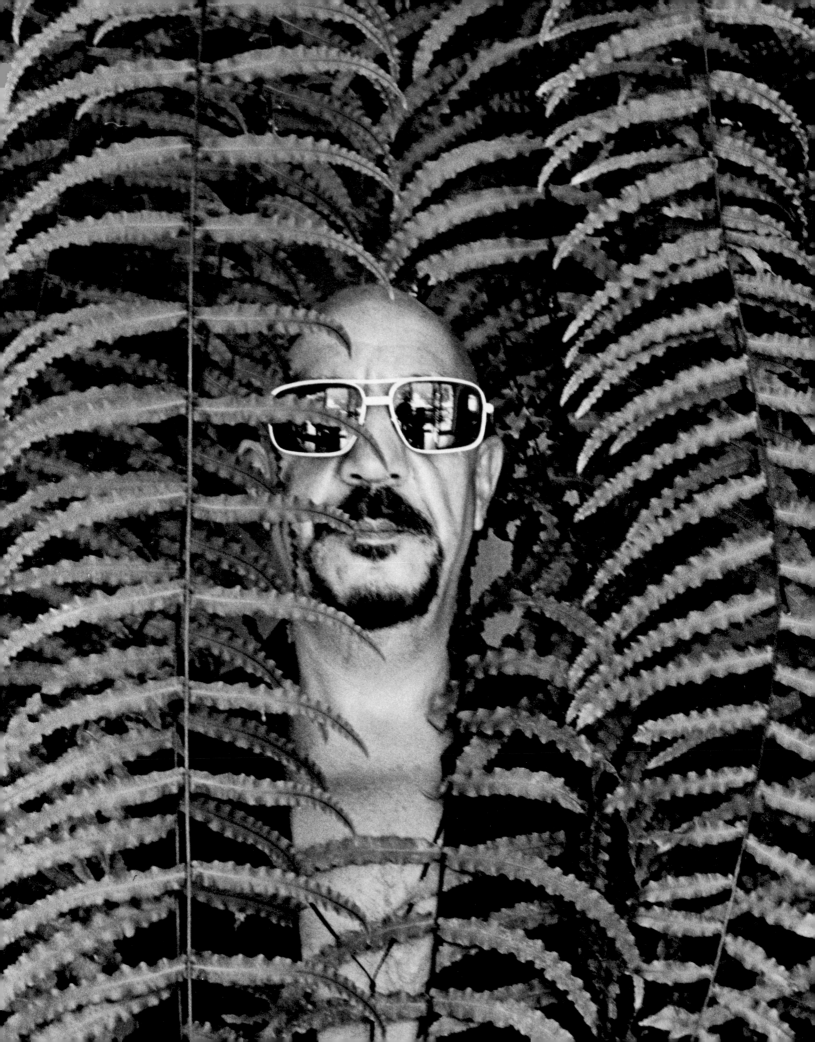

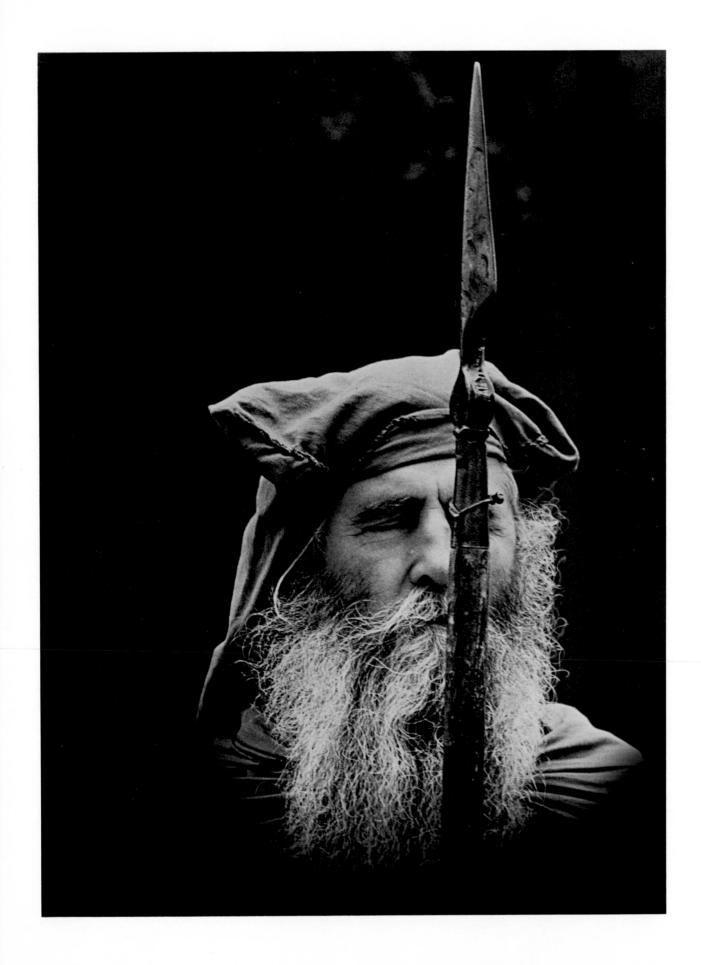

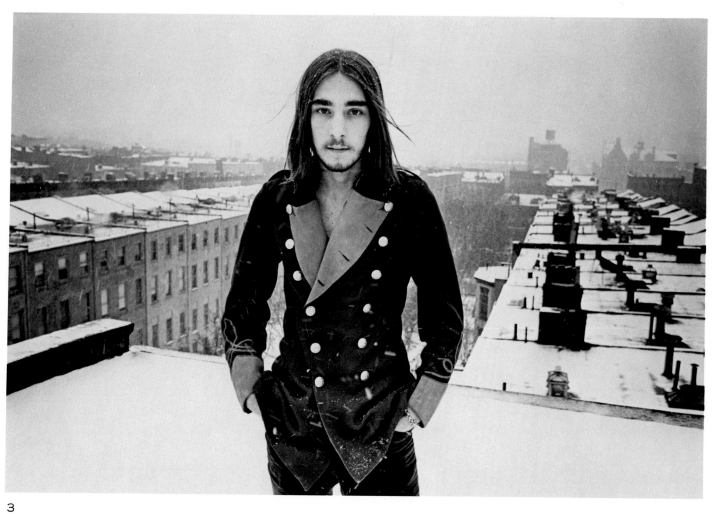

3
Mark Sunn
Sardi Klein

4
Portrait of Peter
Bernis von zur Muehlen

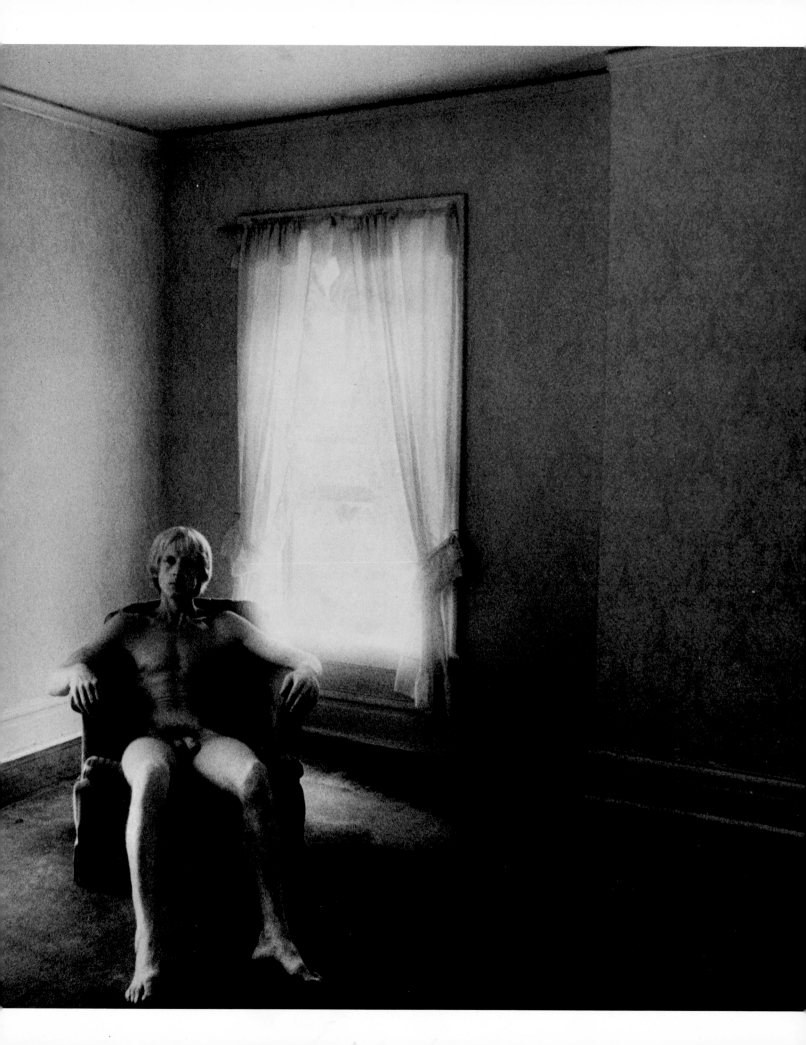

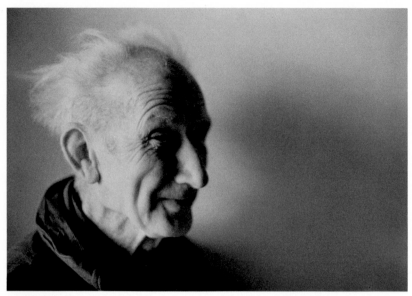

5
Charlie, Syracuse 1976 #1
Jane Courtney Frisse

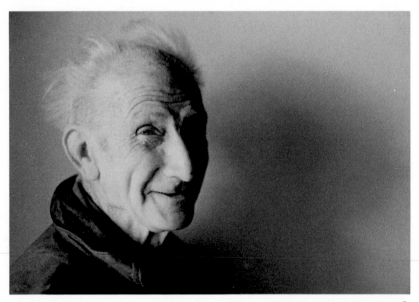

6
Charlie, Syracuse 1976 #2
Jane Courtney Frisse

7
Untitled
Karen Tweedy-Holmes

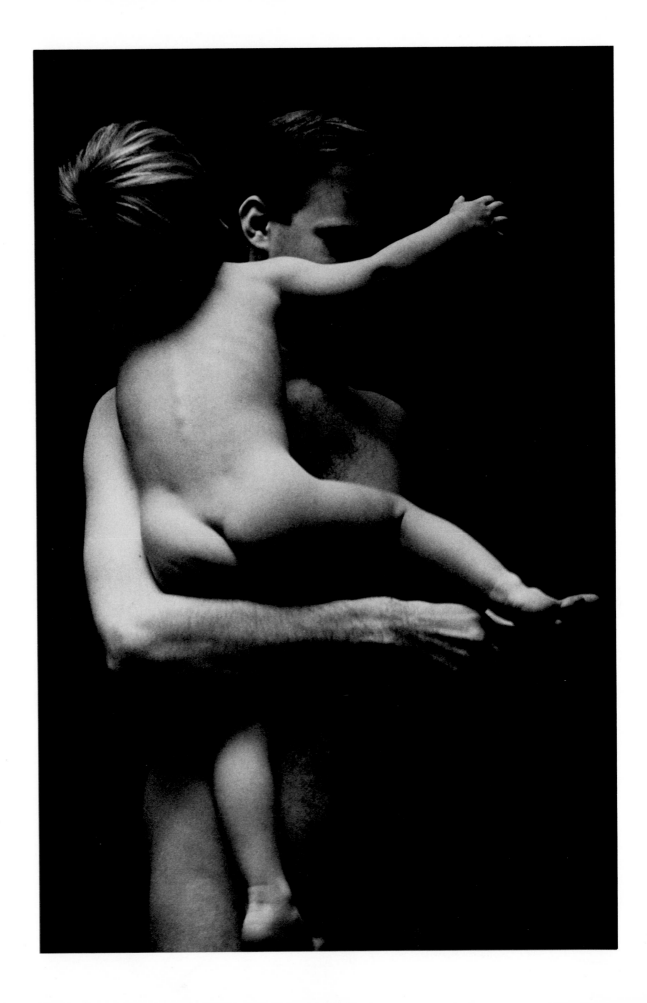

8
Untitled
Karen Tweedy-Holmes

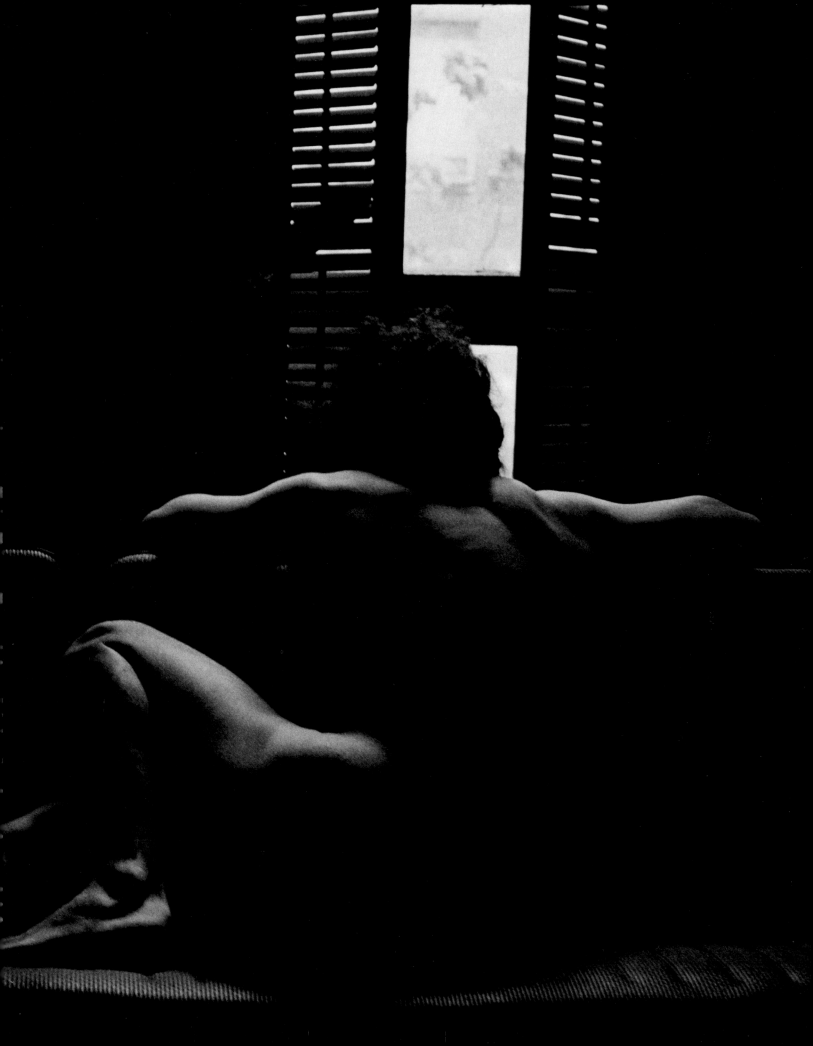

9
Warren Beatty
Frances McLaughlin-Gill

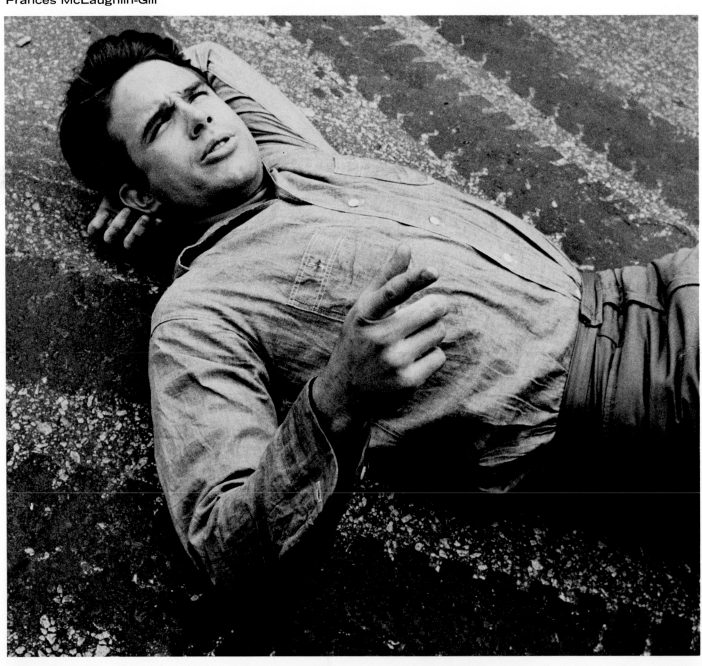

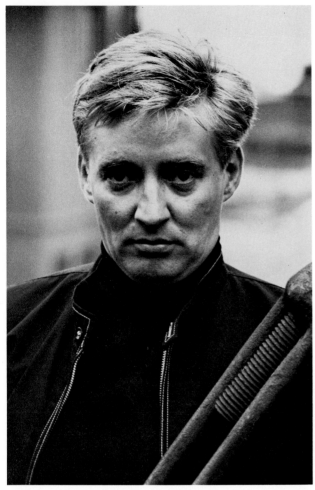

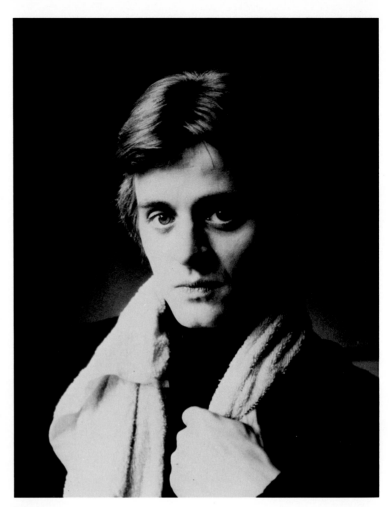

10
Oskar Werner
Frances McLaughlin-Gill

11
Mikhail Baryshnikov
Martha Swope

12
Richard Burton, 1960
Dawn Mitchell Tress

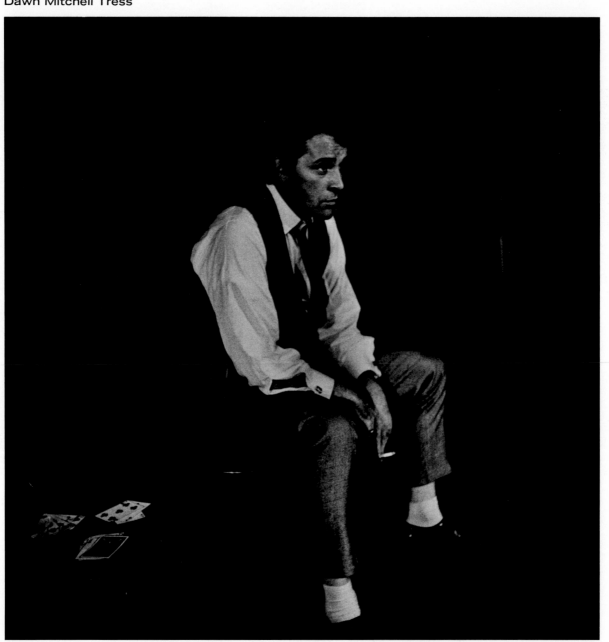

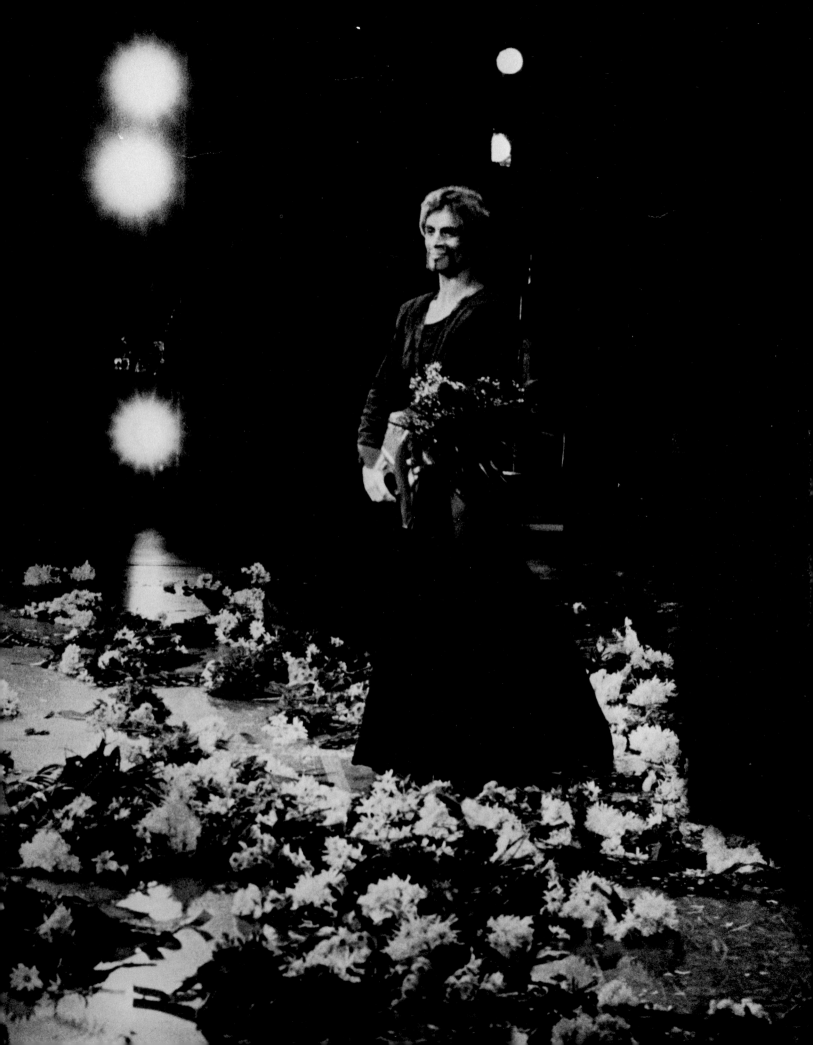

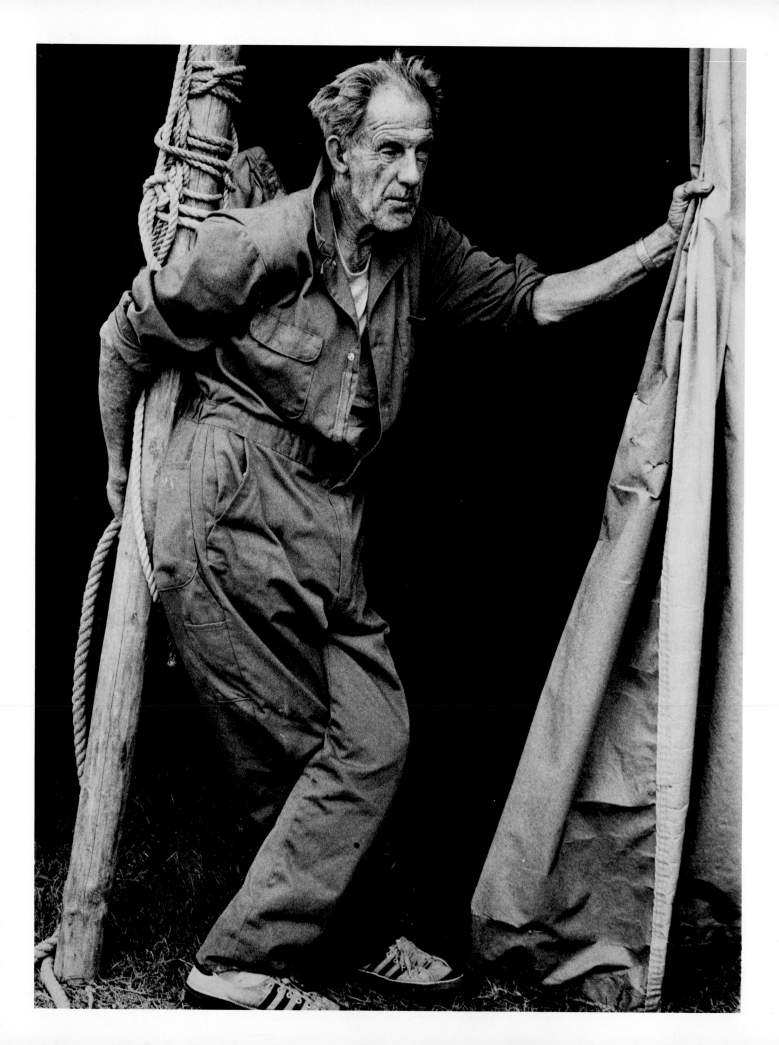

14
Circus Worker
Fran Antmann

15
Circus Clown
Fran Antmann

16
Untitled
Arlene Alda

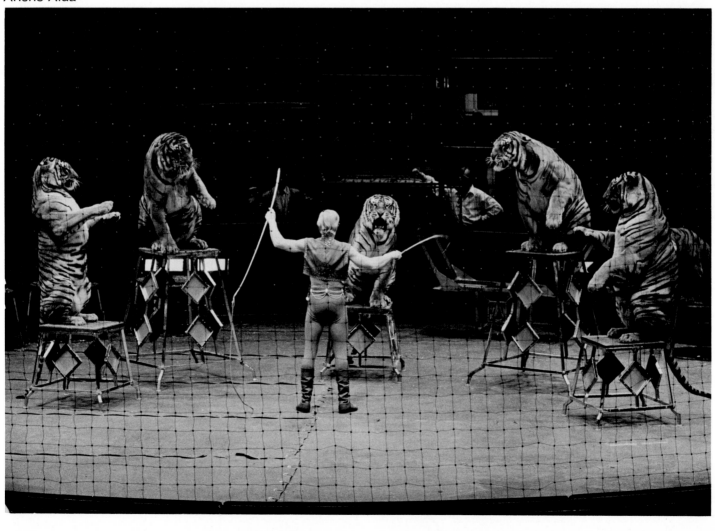

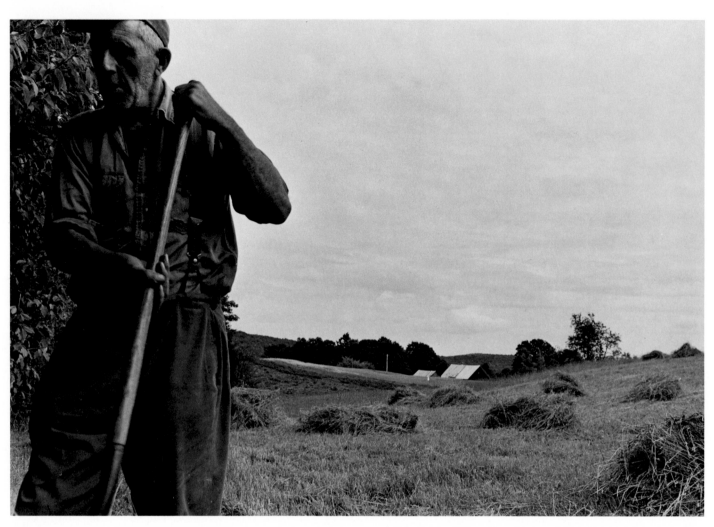

17
Kenneth
Suzanne Opton

18
Raphael Soyer Washing Brushes,
Studio, New York City
Sherry Suris

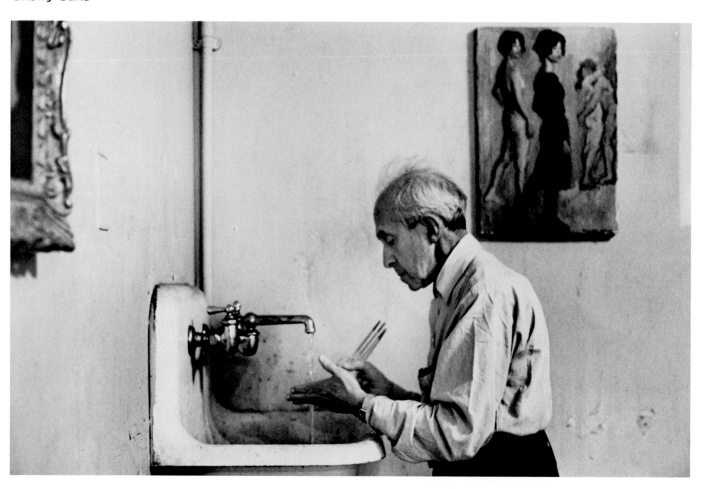

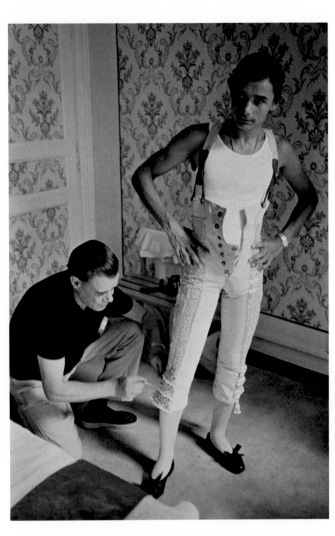

19
Matador with Uncle
Jeannie Baubion-Mackler

20
Weaver, Bonwire, Ghana
Beryl Goldberg

OVERLEAF:
21
Cowboy, Campo de Gato,
Bahia, Summer 1972
Ruth Breil

22
Cowboy with Star Hat,
Bahia, Summer 1972
Ruth Breil

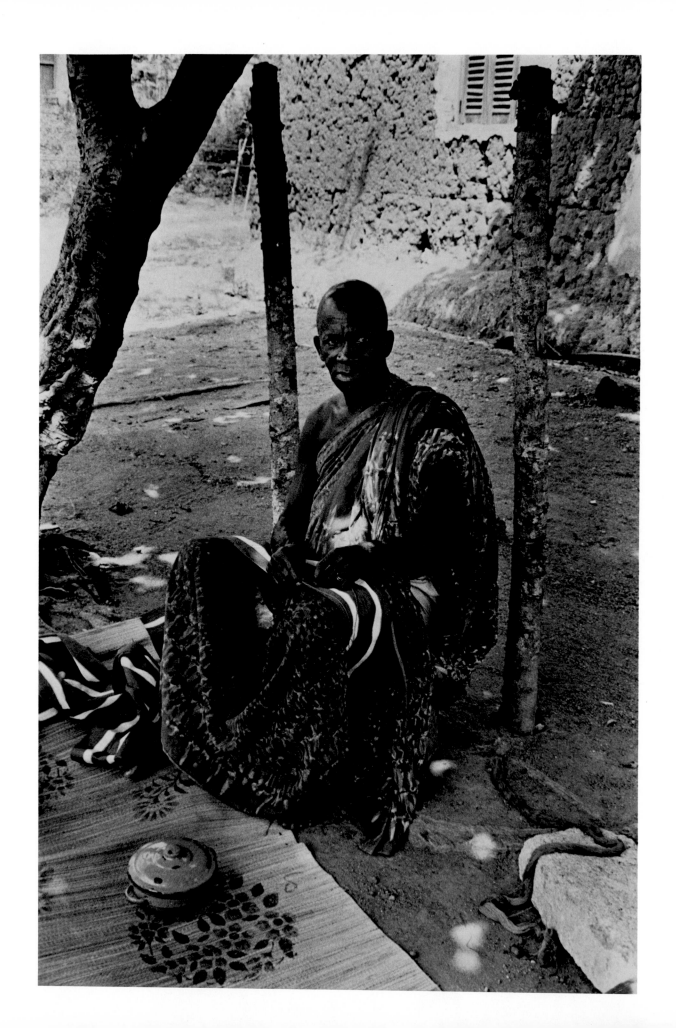

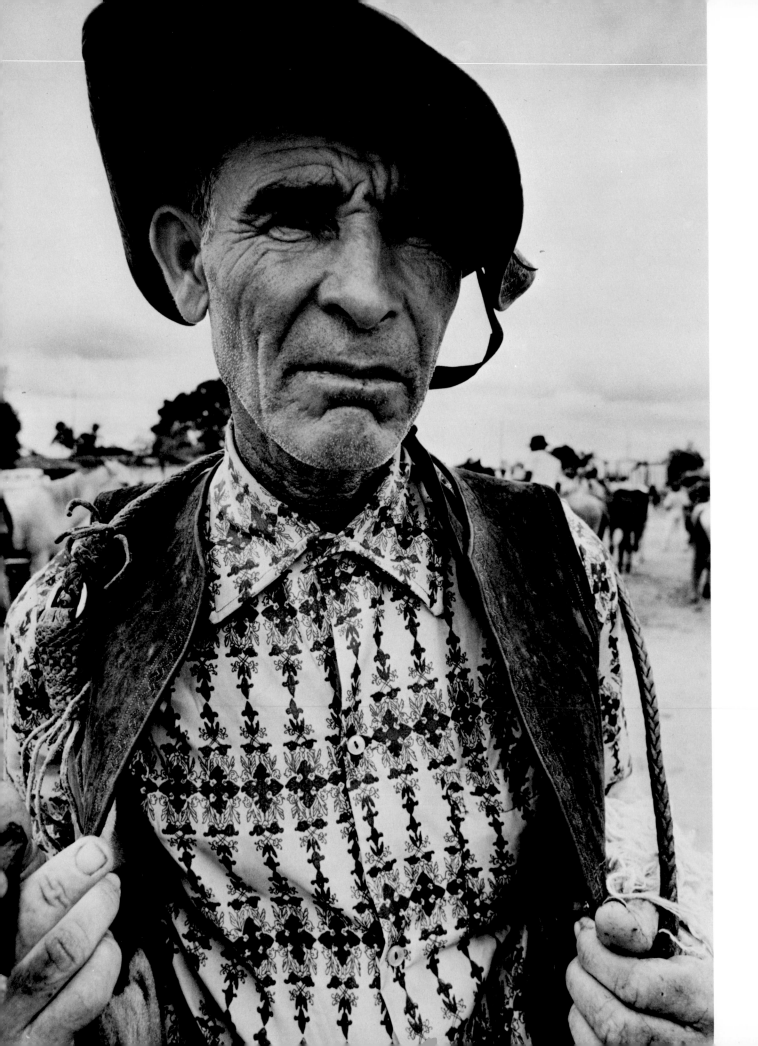

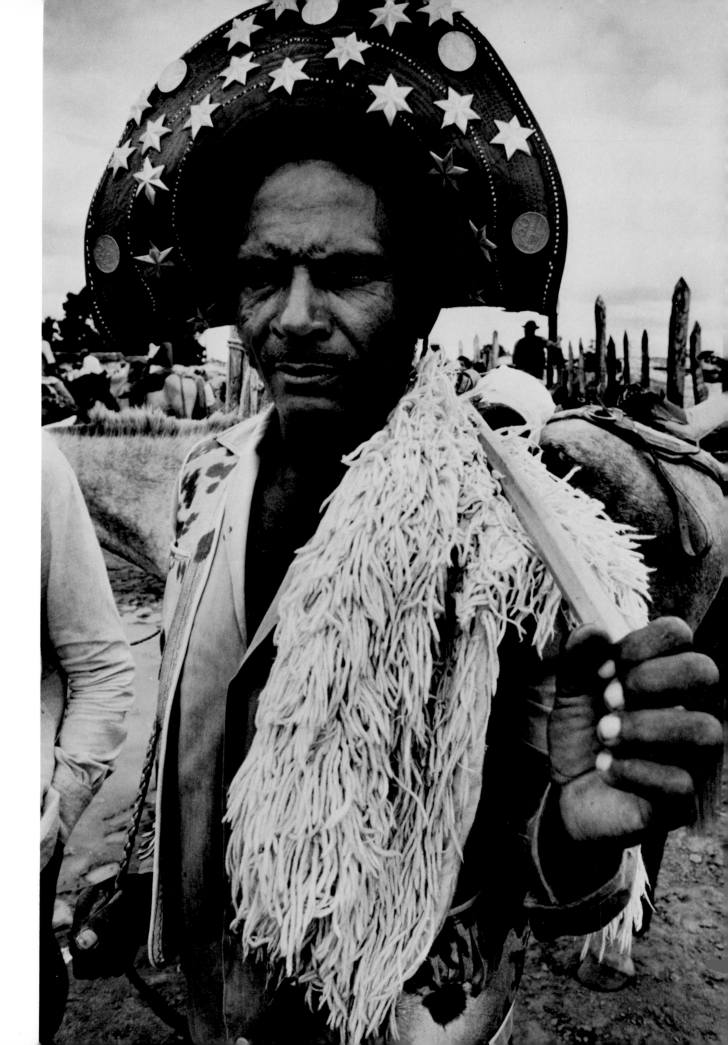

23
For Chief Judge
Diana Mara Henry

24
Politician, New York City
L. Fornasieri Gold

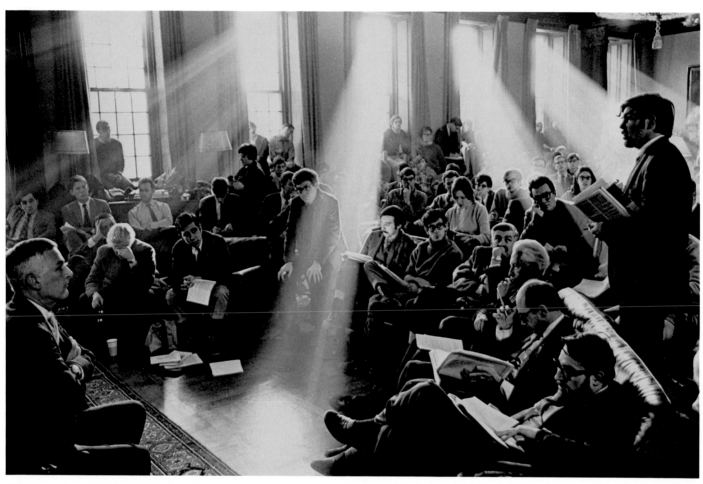

25
Student Faculty Advisory Committee, Harvard
Diana Mara Henry

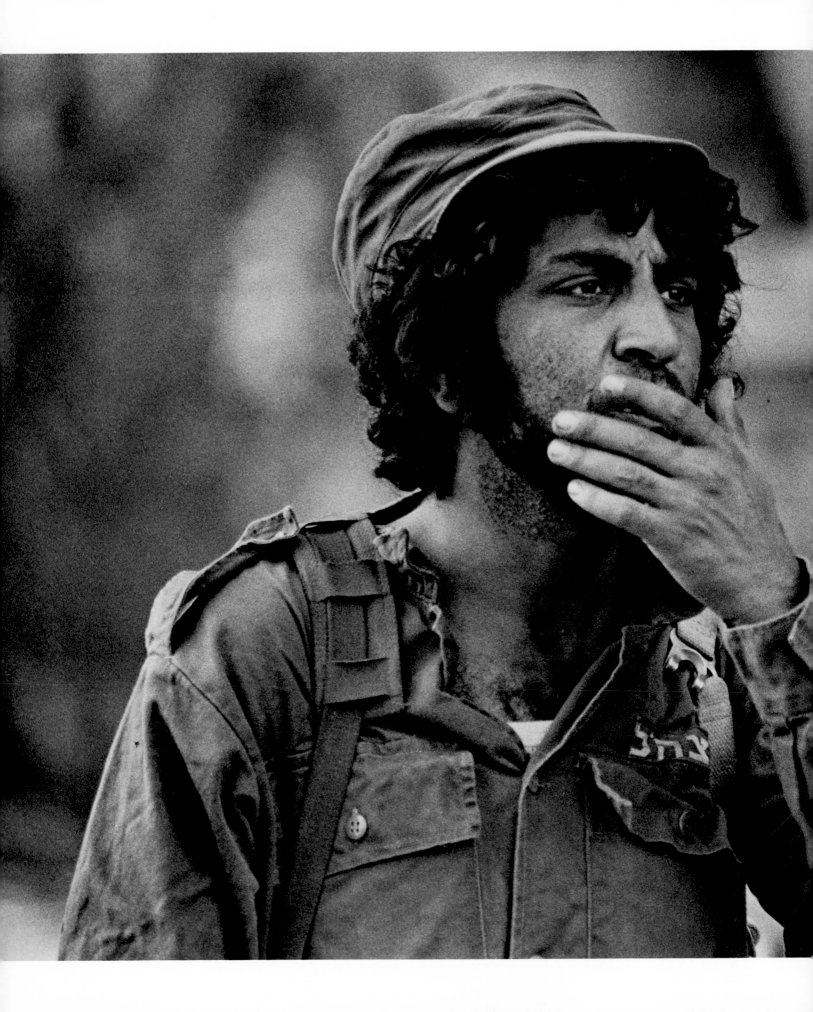

26
Israeli Soldier, Golan Heights, October 1973
Eva Rubinstein

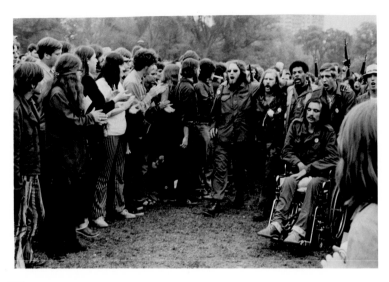

27
Vietnam Veterans Against the War
Diana Mara Henry

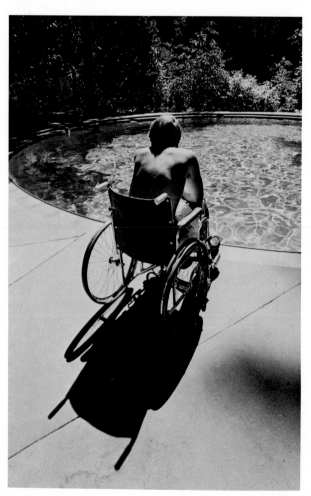

28
Vietnam Veteran, California 1974
Eva Rubinstein

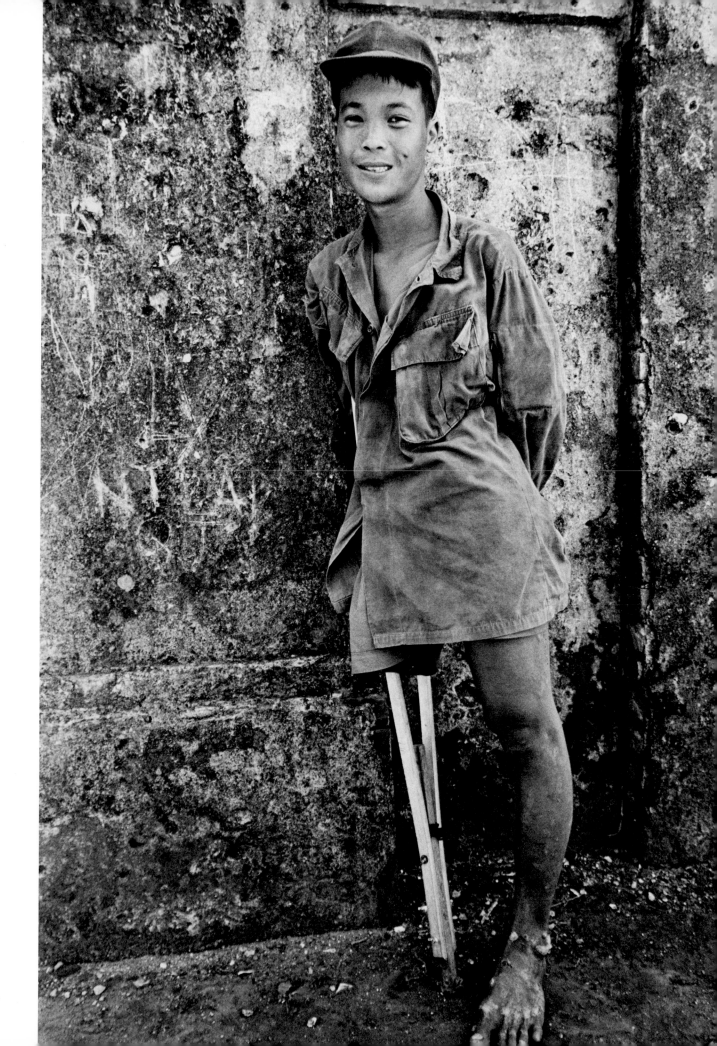

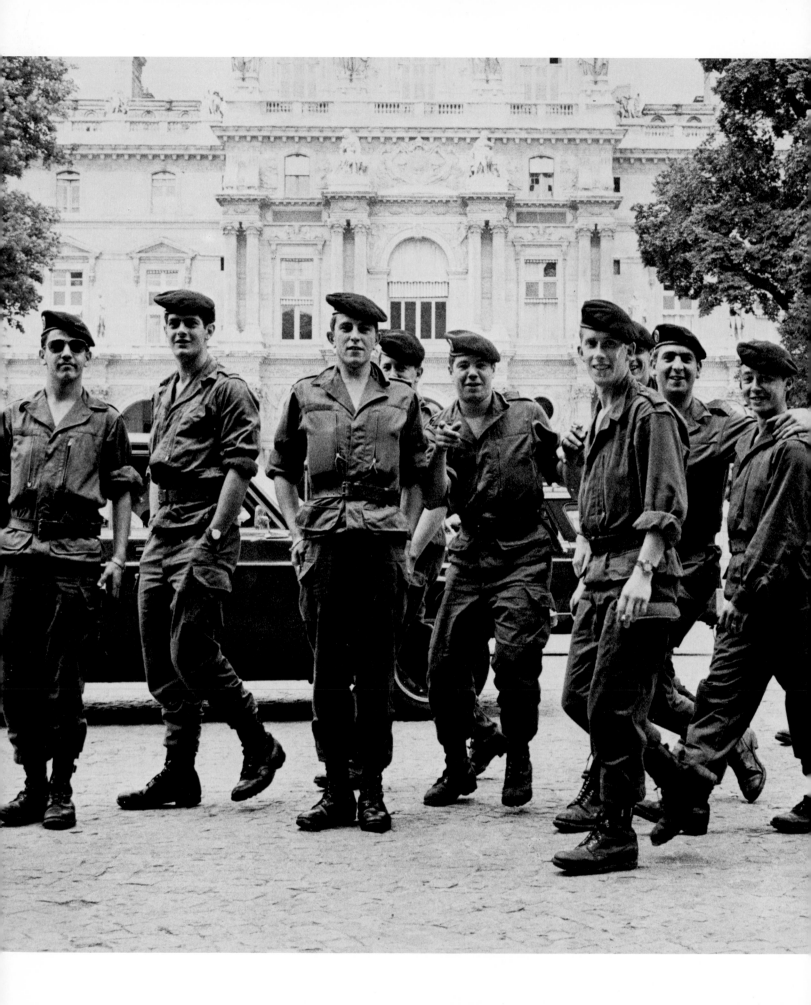

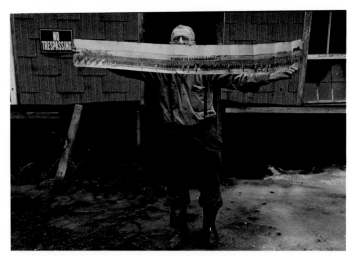

31
Untitled
Suzanne Opton

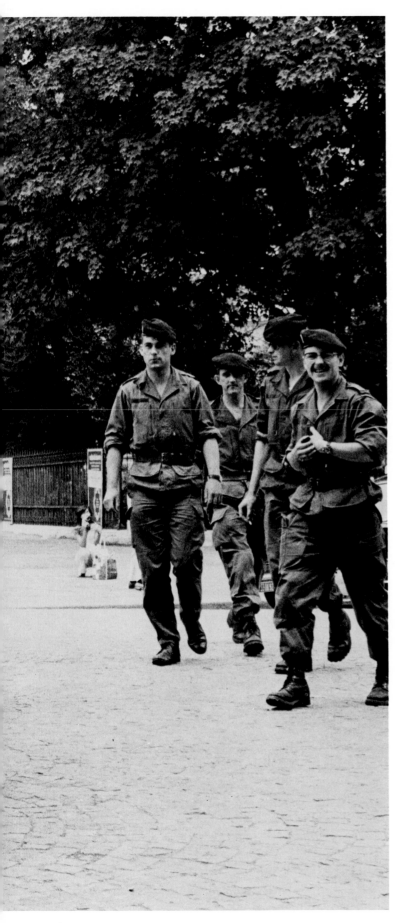

30
Soldiers in France, 1973
Flo Fox

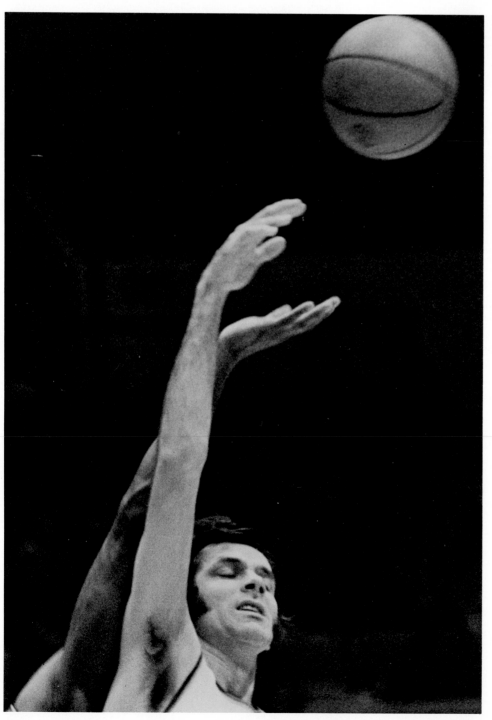

32
New York Knicks 1975,
Dave De Busschere
Trudy Rosen

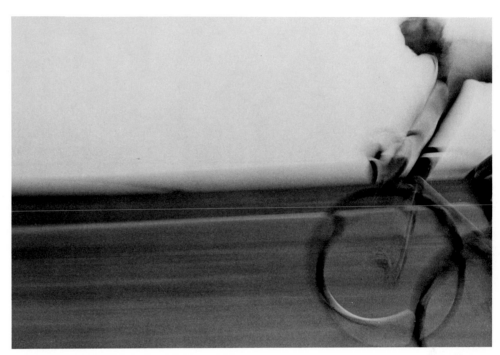

33
Untitled
Carolee Campbell

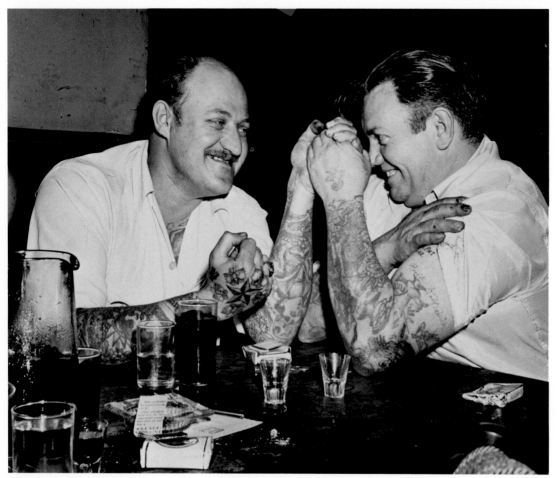

34
Test of Strength, Bowery, New York City
Erika Stone

35
Rugby, Aspen, Colorado
Alison Wachstein

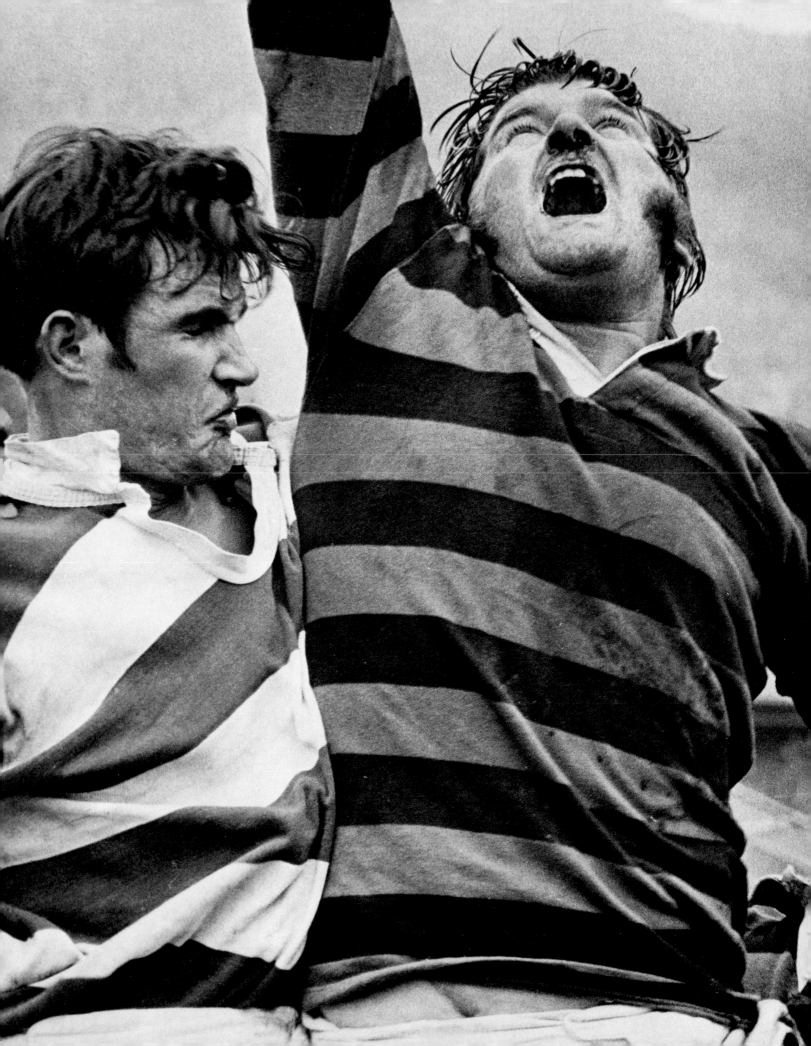

36
Miss World/U.S.A. Beauty Pageant, 1976
Bobbi Carrey

37
Untitled
Carolee Campbell

38
Untitled
Carolee Campbell

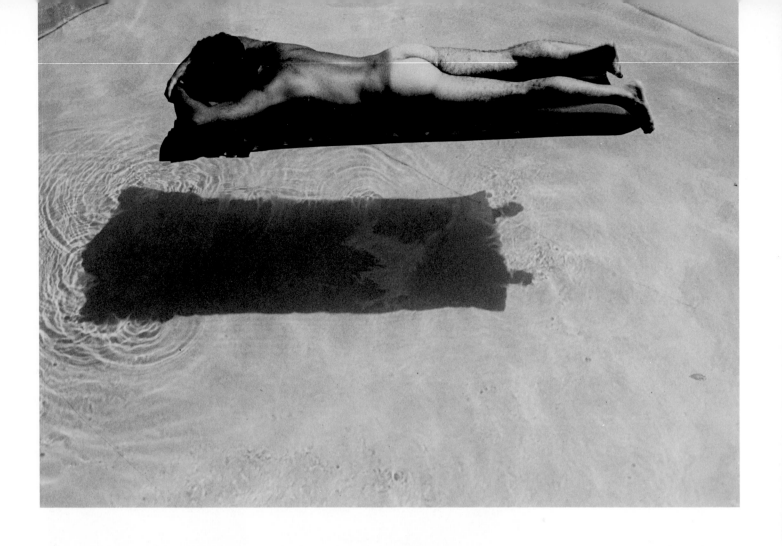

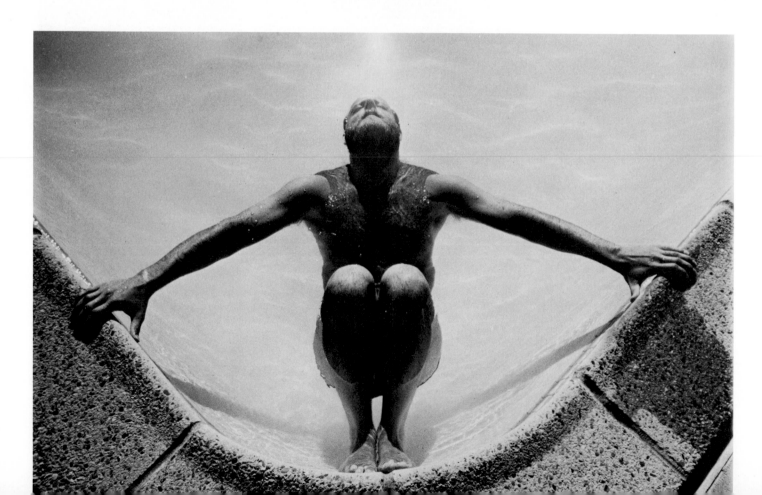

39
The Float
Ann Mandelbaum

40
Peter in the Pool
Joyce Ravid

41
Untitled
Abby Robinson

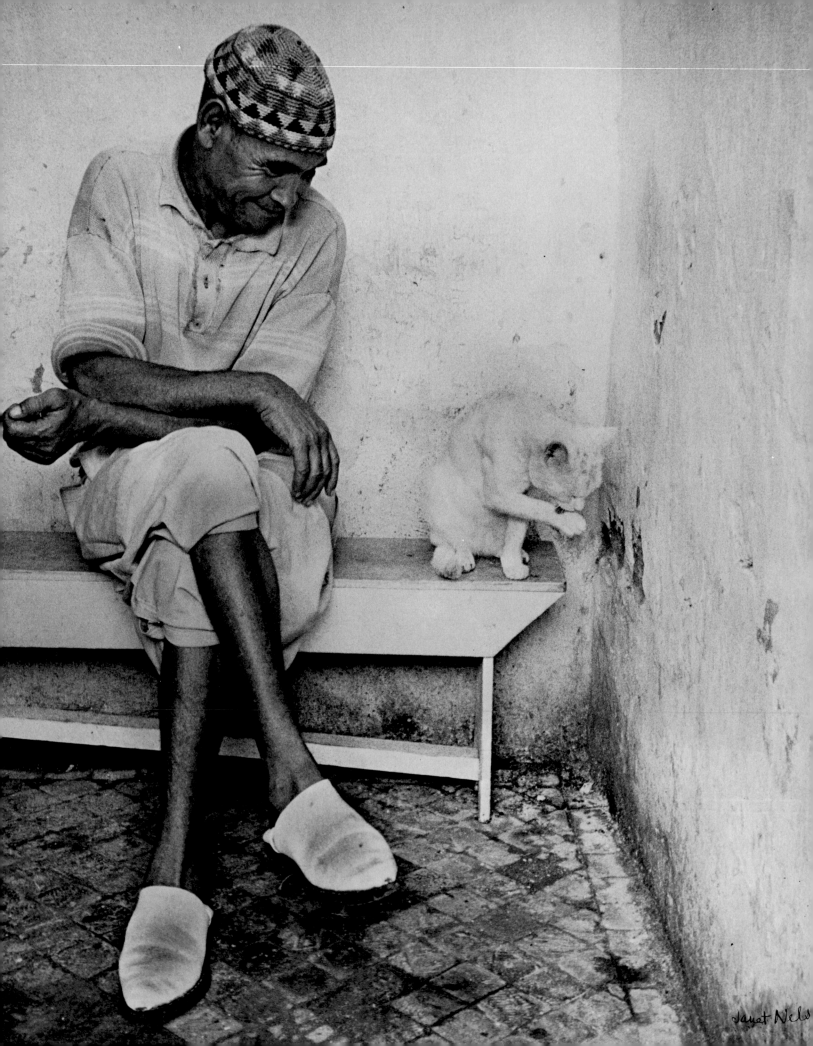

42
Untitled
Janet Nelson

43
Look-Alikes,
Central Park,
New York City
Erika Stone

44
Eli and Randy
Kathryn Abbe

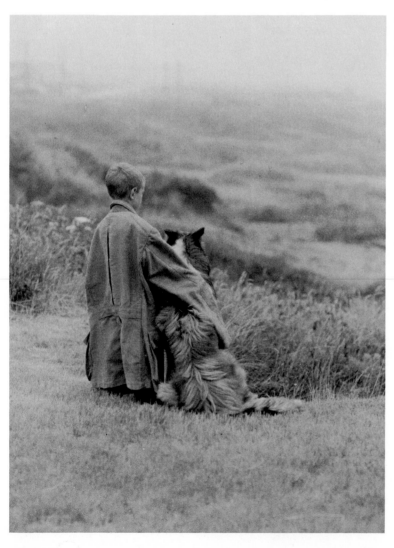

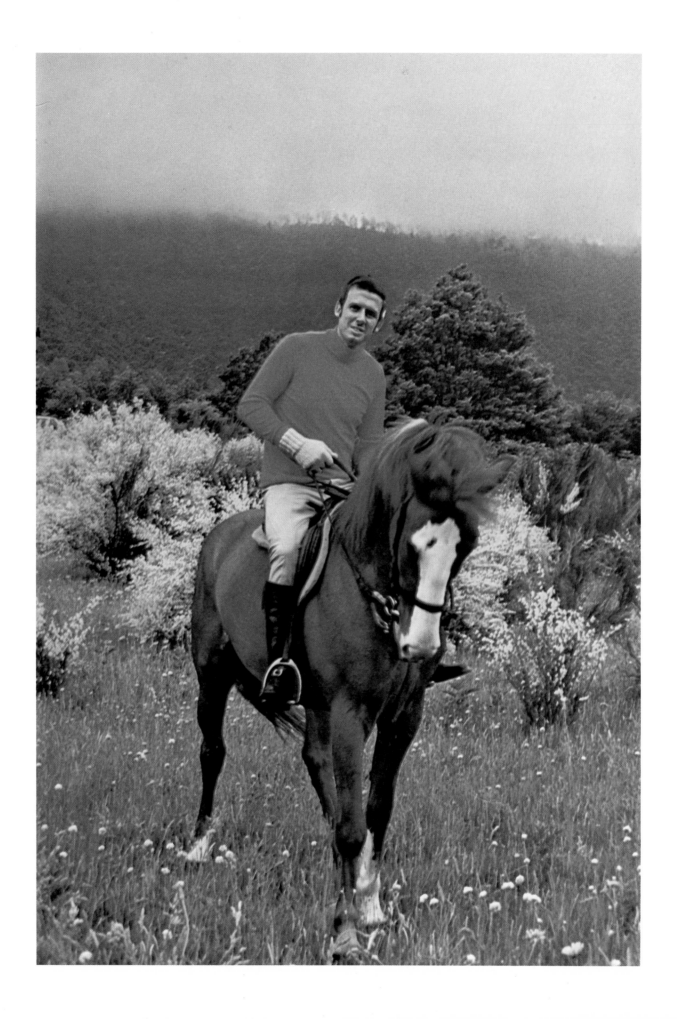

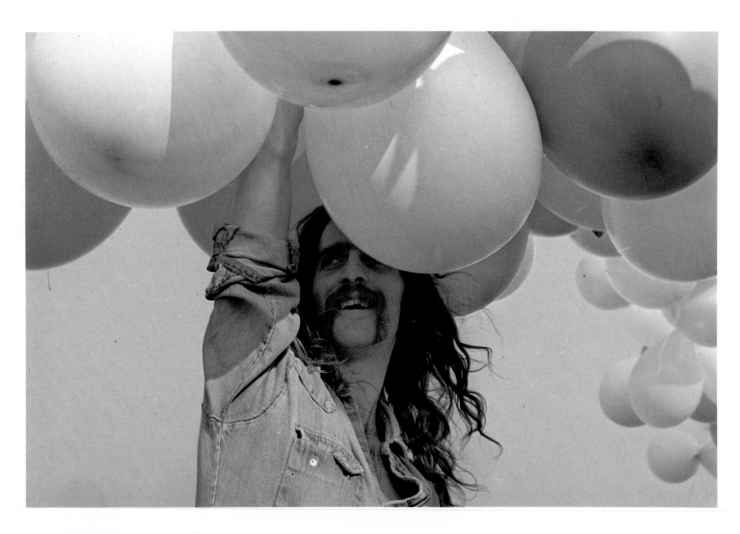

Avant Garde Festival, 1975
Dannielle B. Hayes

Untitled
Connie Moberley

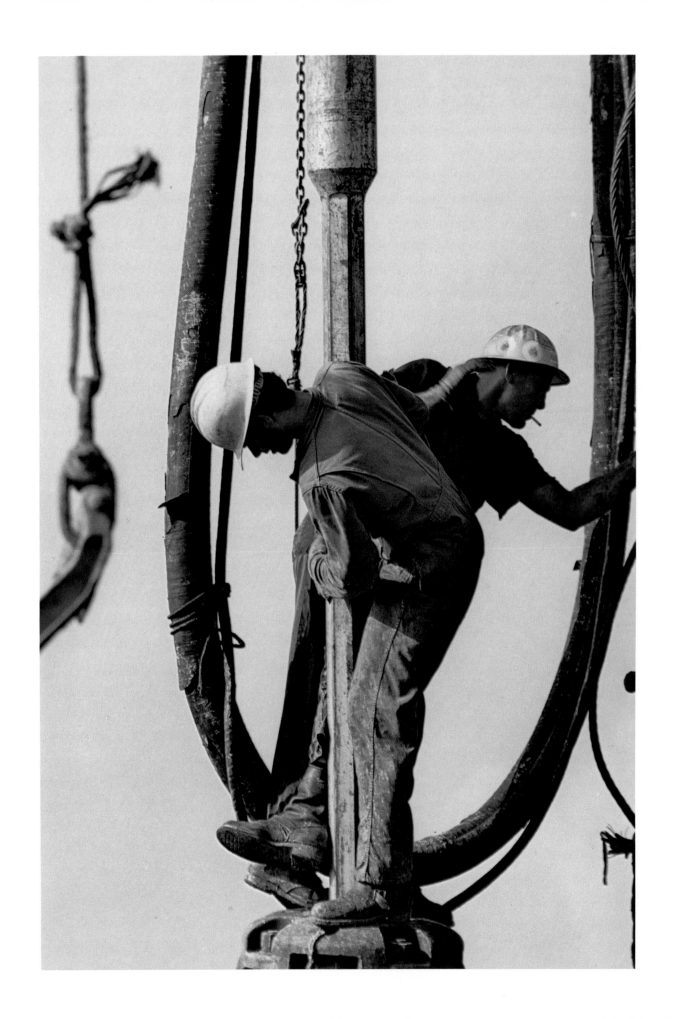

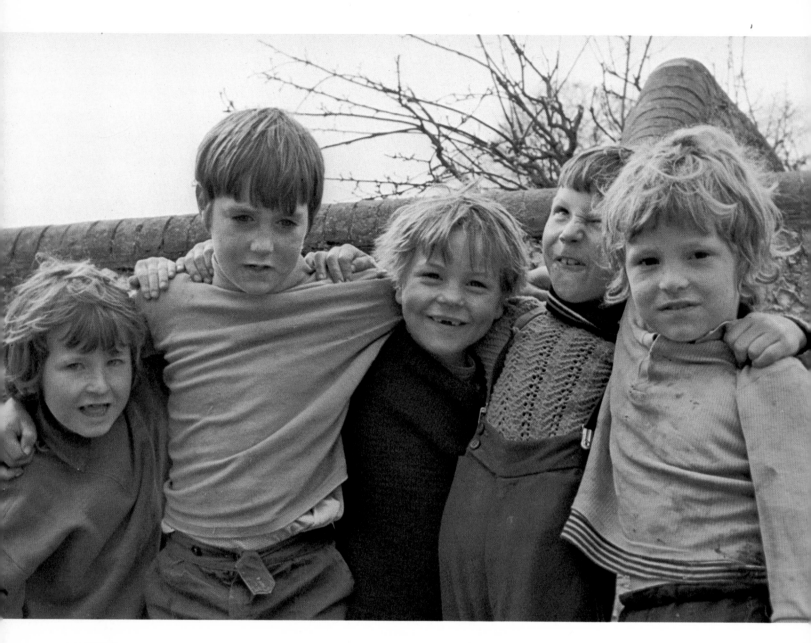

Untitled
Robin Schwartz

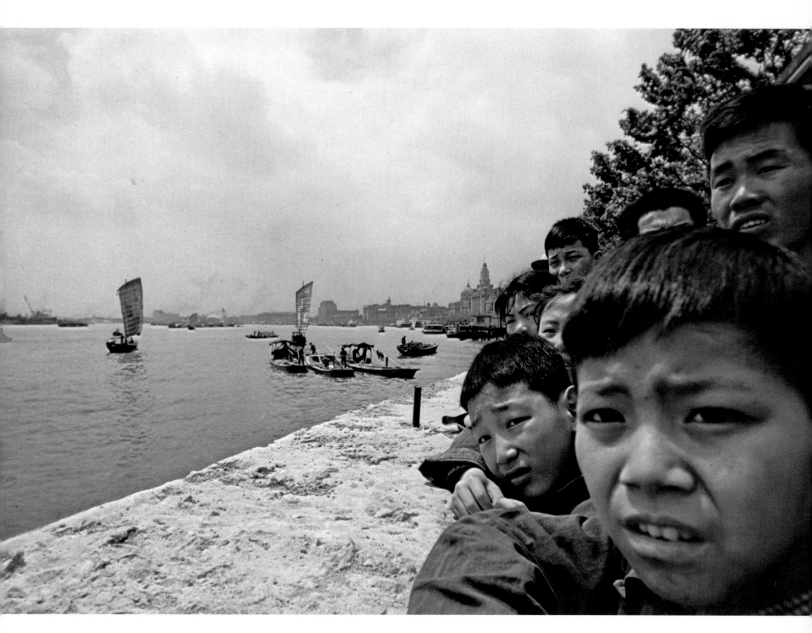

Peking, 1975
Marjorie Neikrug

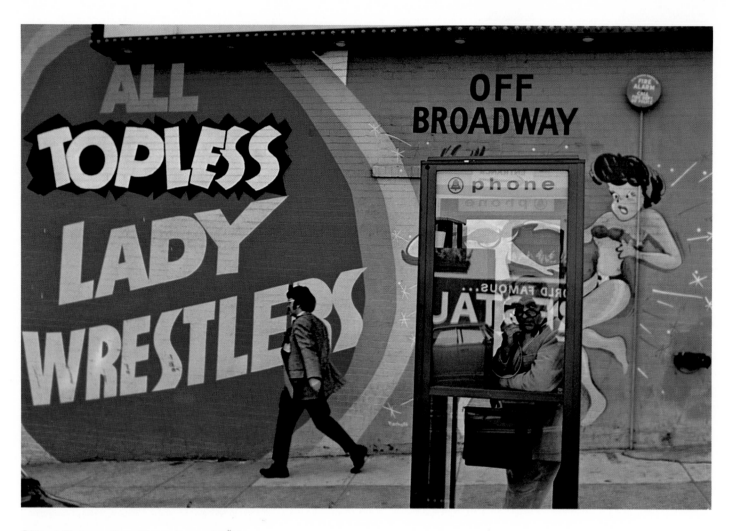

Street Scene, San Francisco, 1976
Kathryn Abbe

Untitled
Robin Schwartz

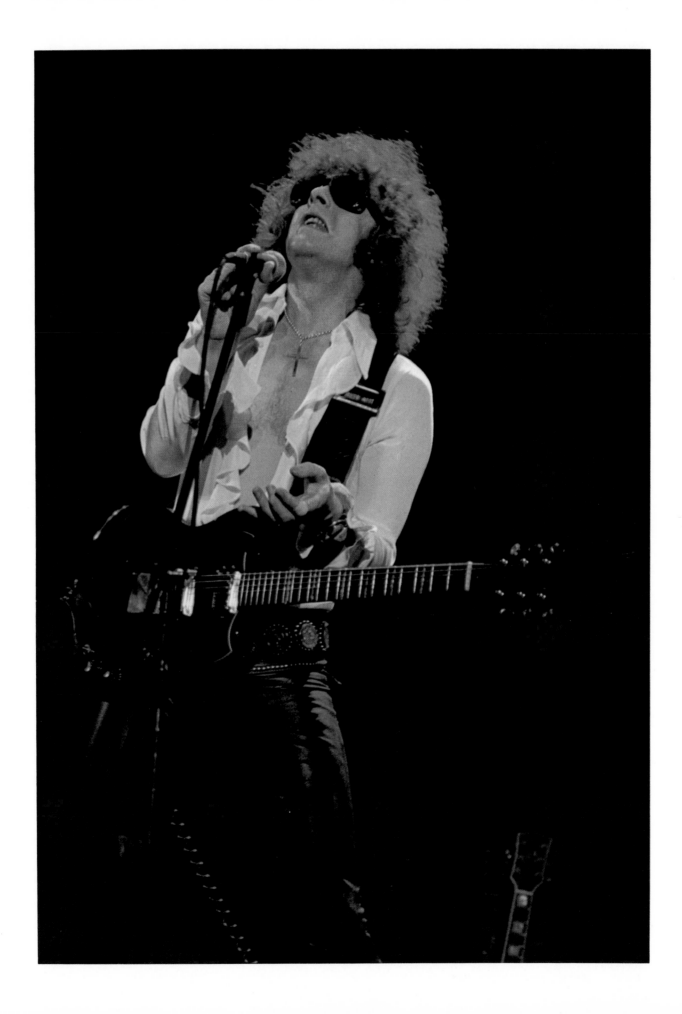

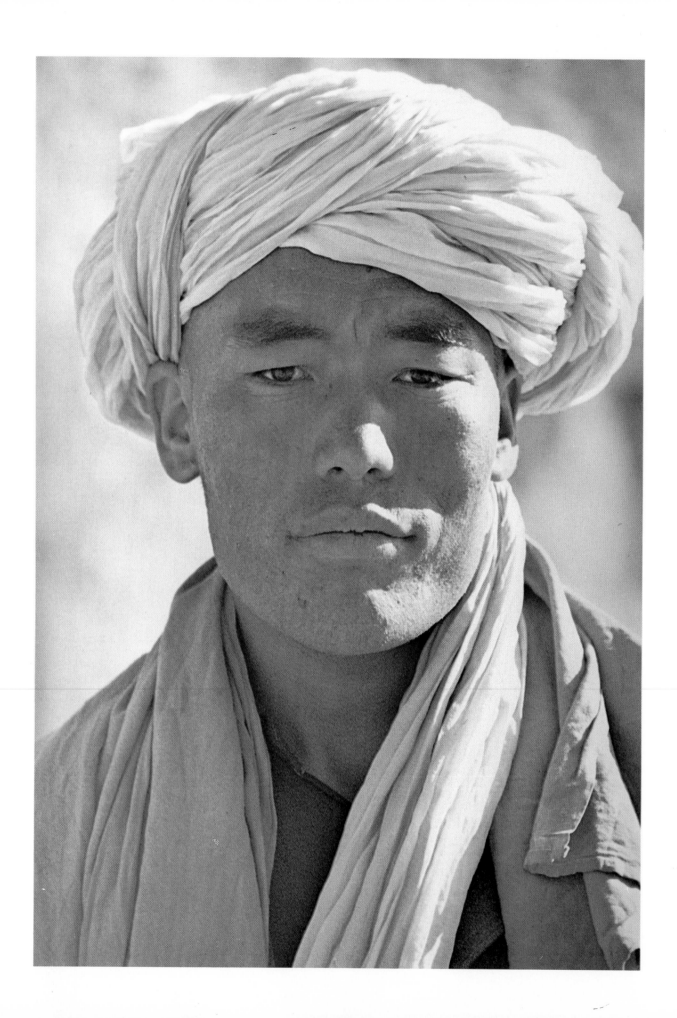

Bamiyan Afghanistan, 1973
Barbara Gluck

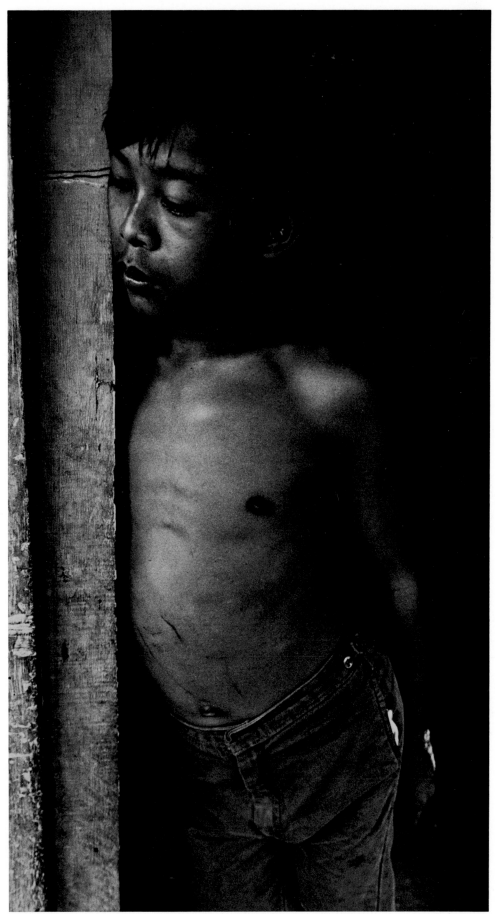

45
Shoeshine Boy,
Saigon, Vietnam, 1973
Barbara Gluck

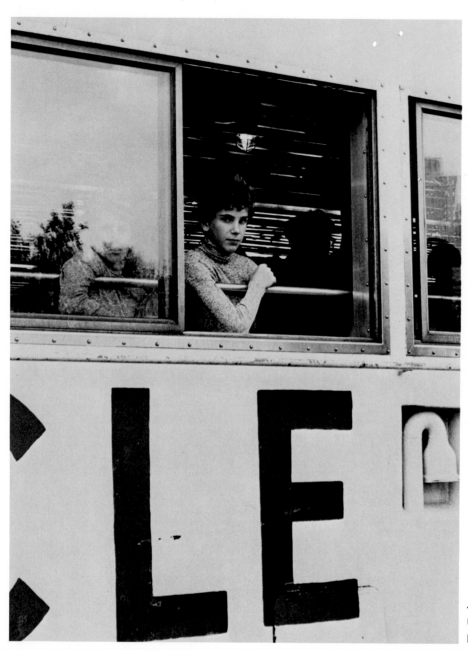

46
Untitled
Diane Harrington

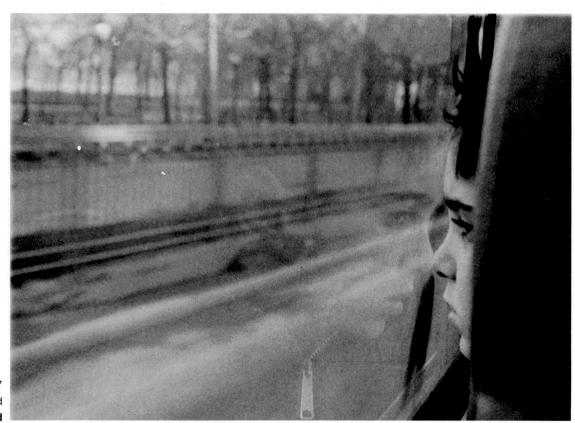

47
Untitled
Eva Seid

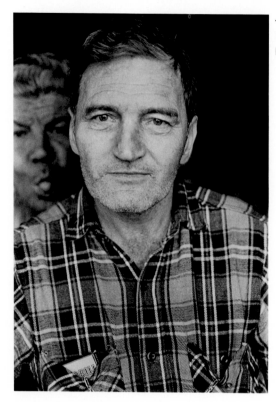

48
Bill, April 1973
Patt Blue

49
Shimon
Judith Turner

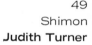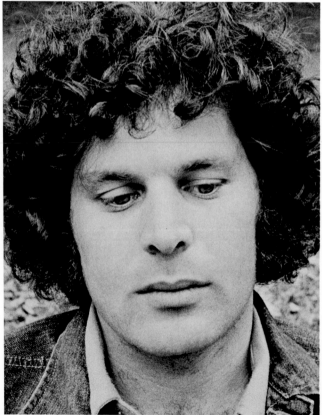

50
Jeep, 1974
Linda Joan Miller

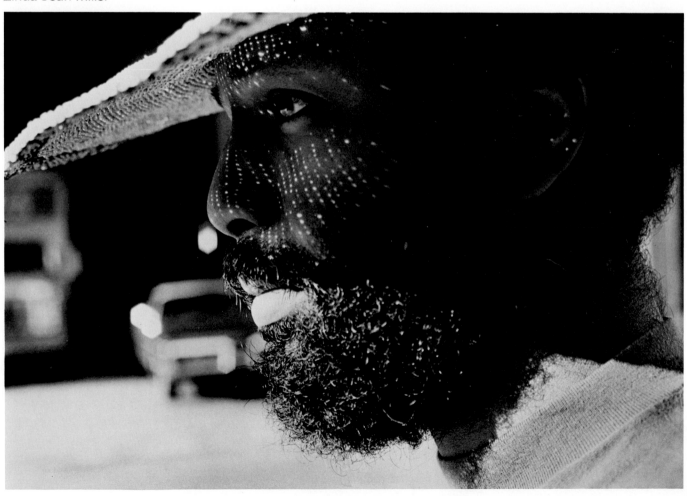

51
Jimmy Carter
Patricia Caulfield

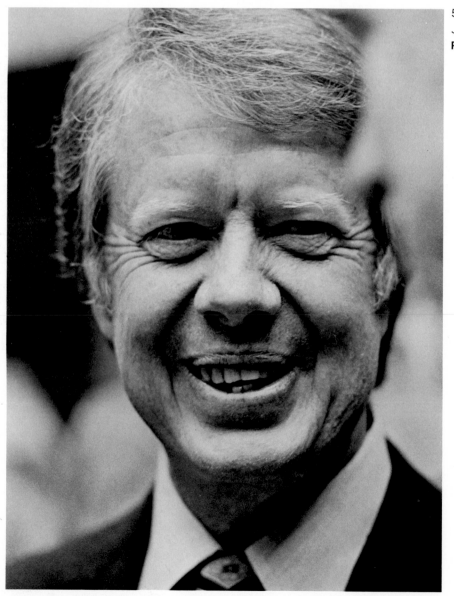

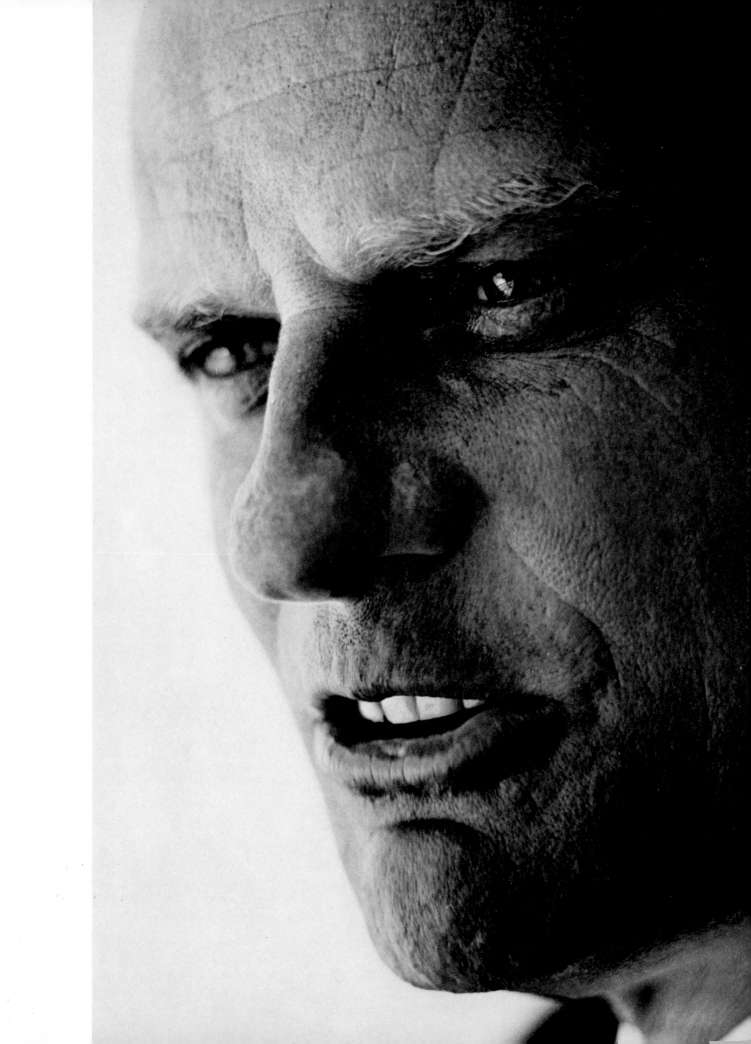

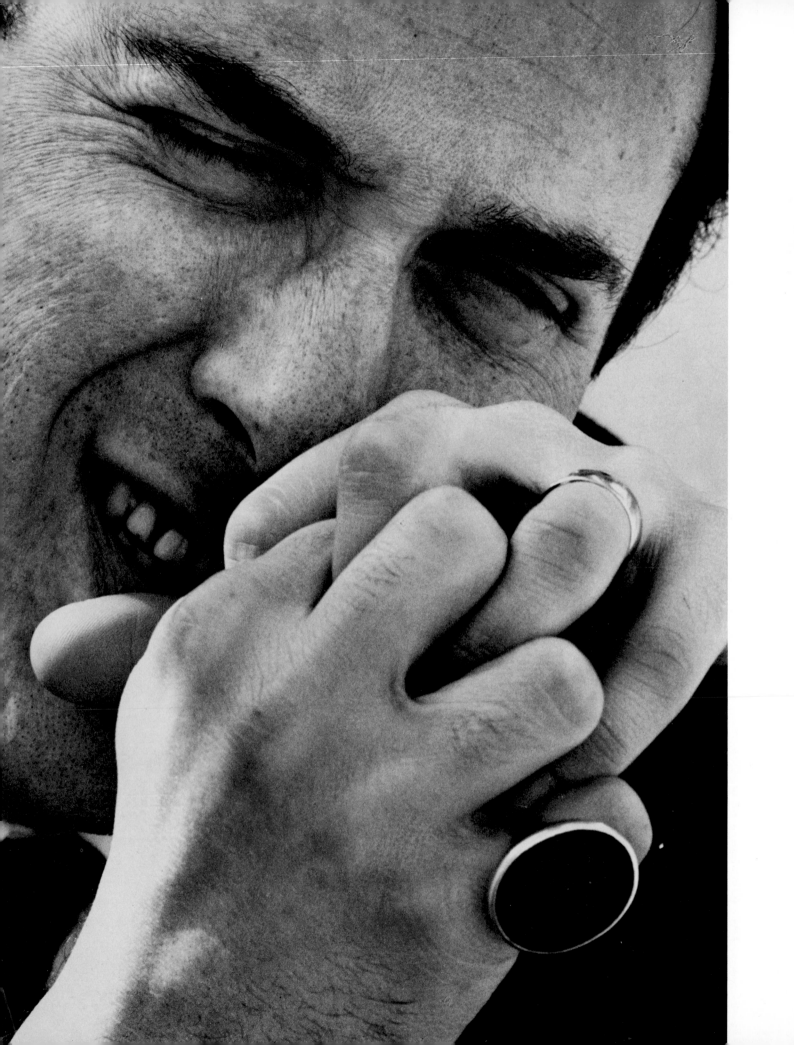

53
Harold Pinter
Frances McLaughlin-Gill

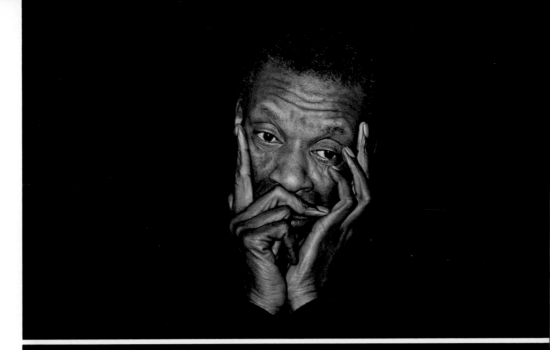

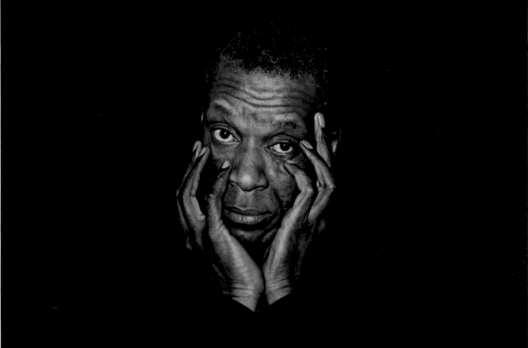

54
Moses Gunn #1
Mary Ellen Andrews

55
Moses Gunn #2
Mary Ellen Andrews

56
Moses Gunn #3
Mary Ellen Andrews

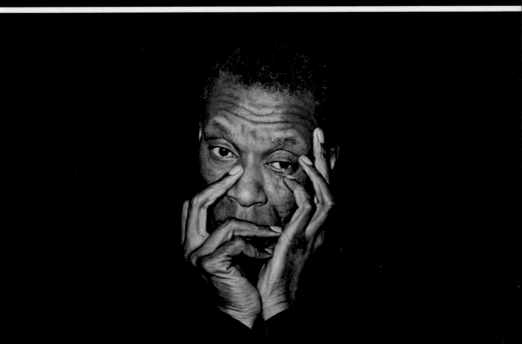

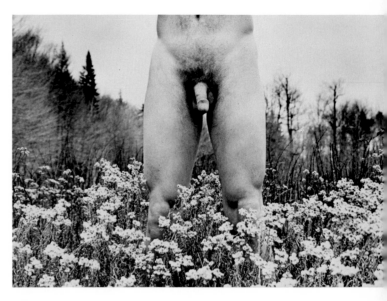

58
Mortimer, October 1975
Patt Blue

57
Chas, March 1973
Patt Blue

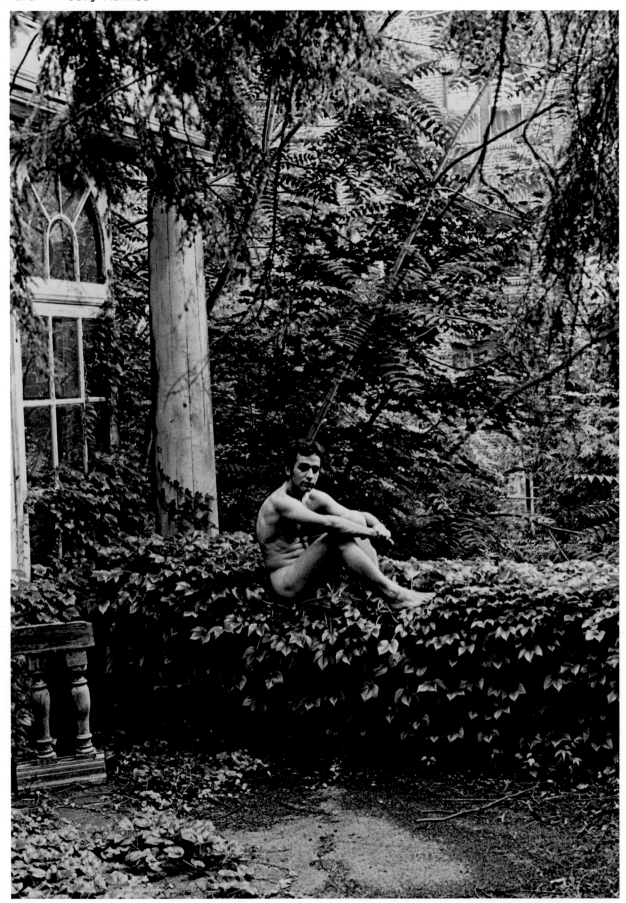

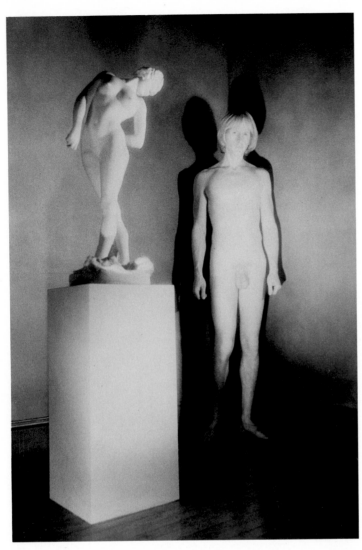

61
Peter
Bernis von zur Muehlen

62
Untitled
Karen Tweedy-Holmes

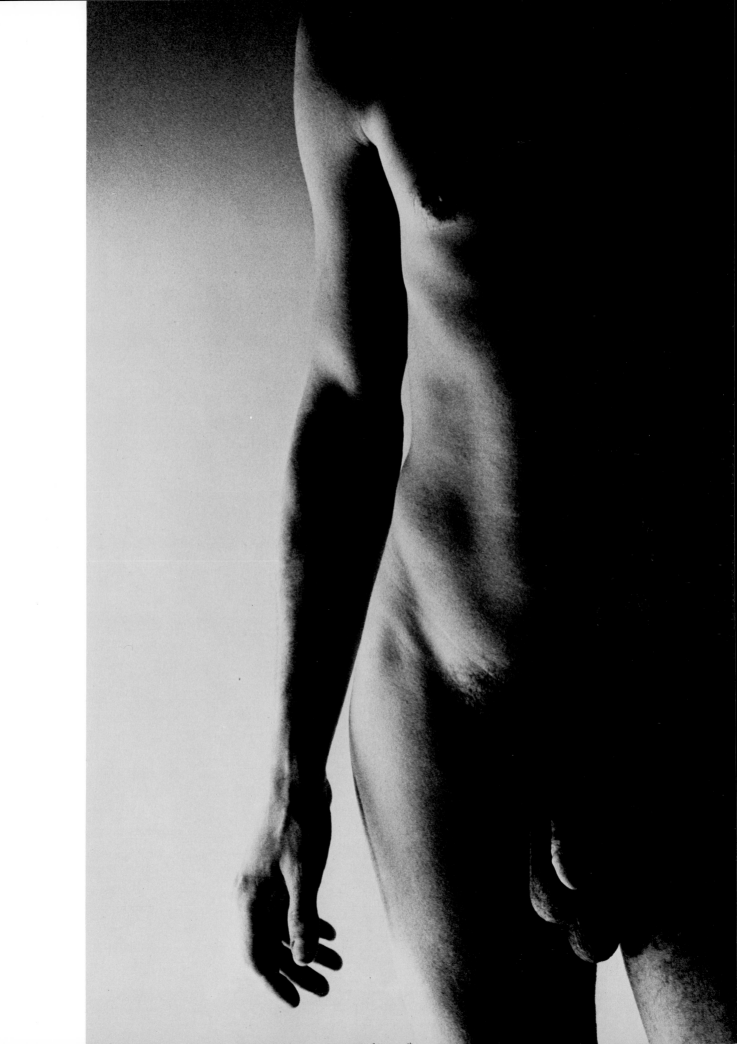

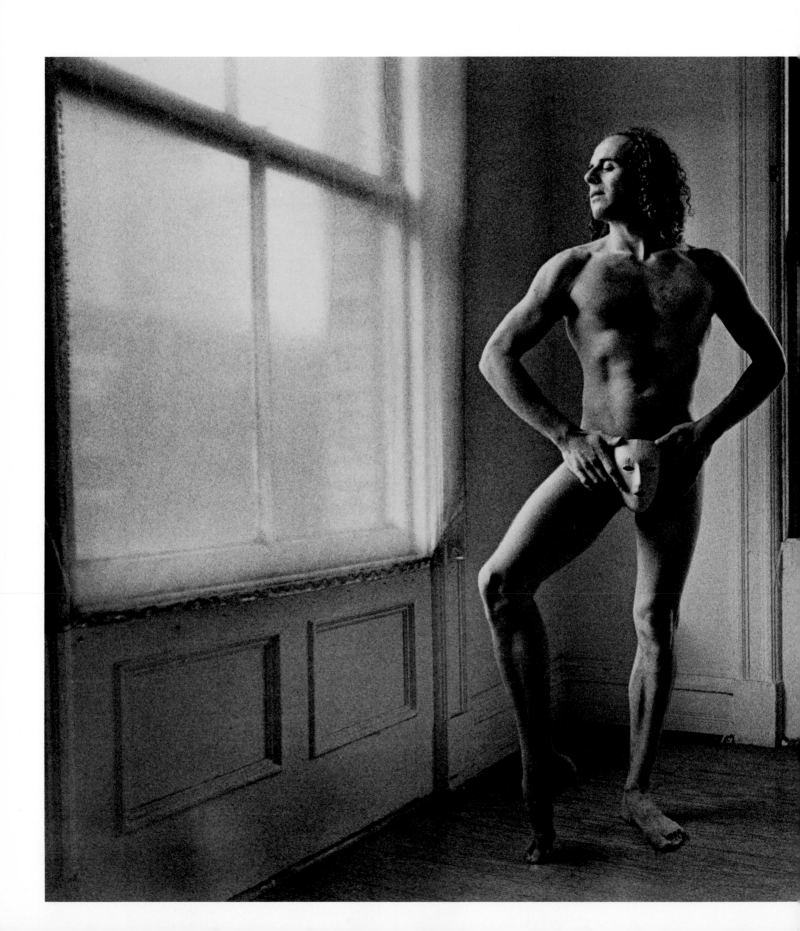

63
Untitled
Mary Ellen Mark

OVERLEAF:
64
Willard's Fist, 1942
Barbara Morgan

65
Untitled
Dianora Niccolini

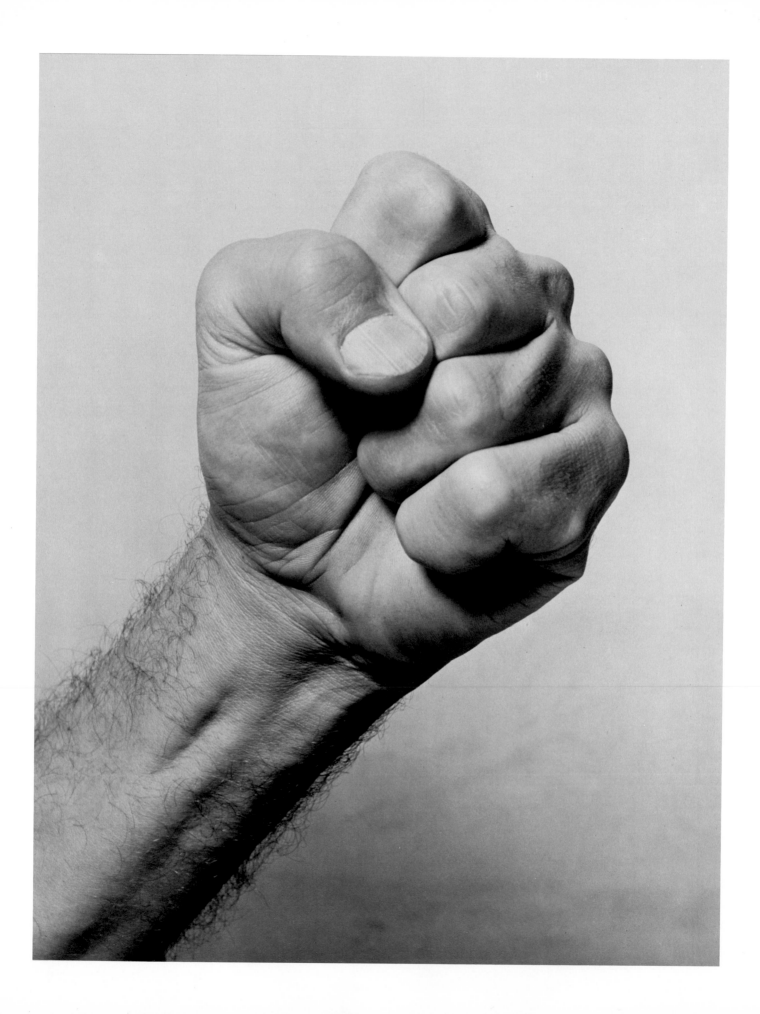

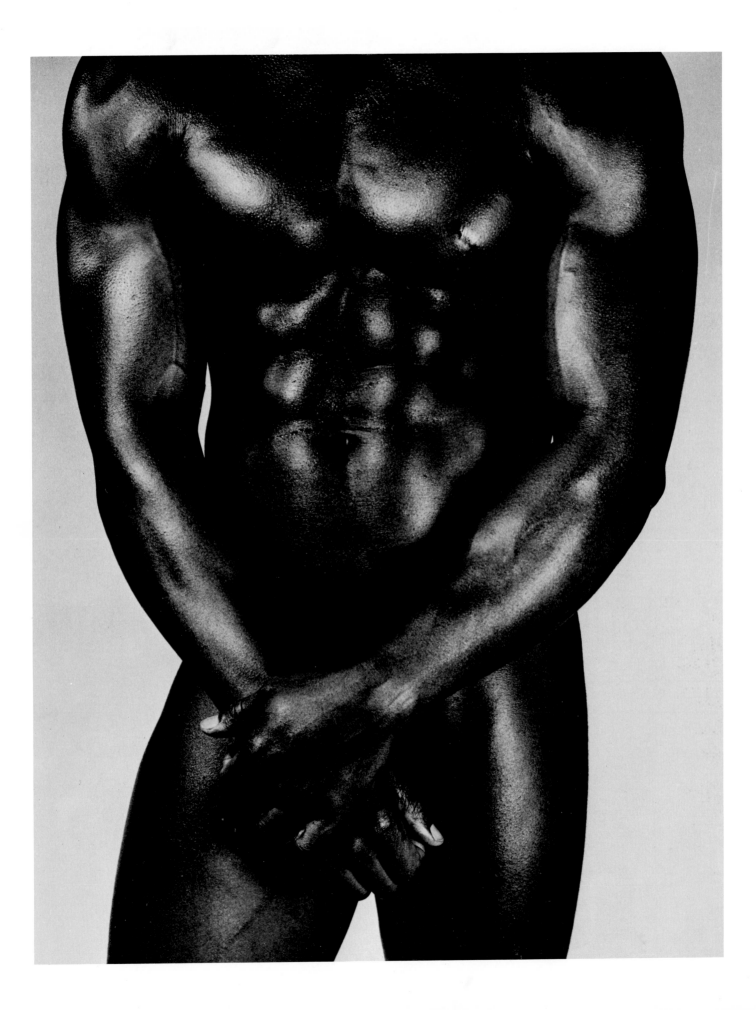

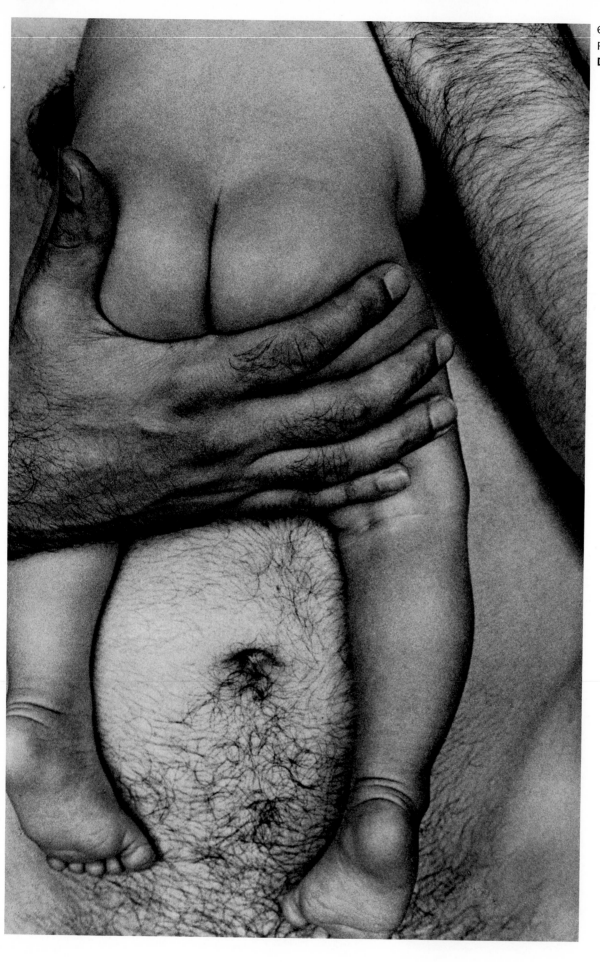

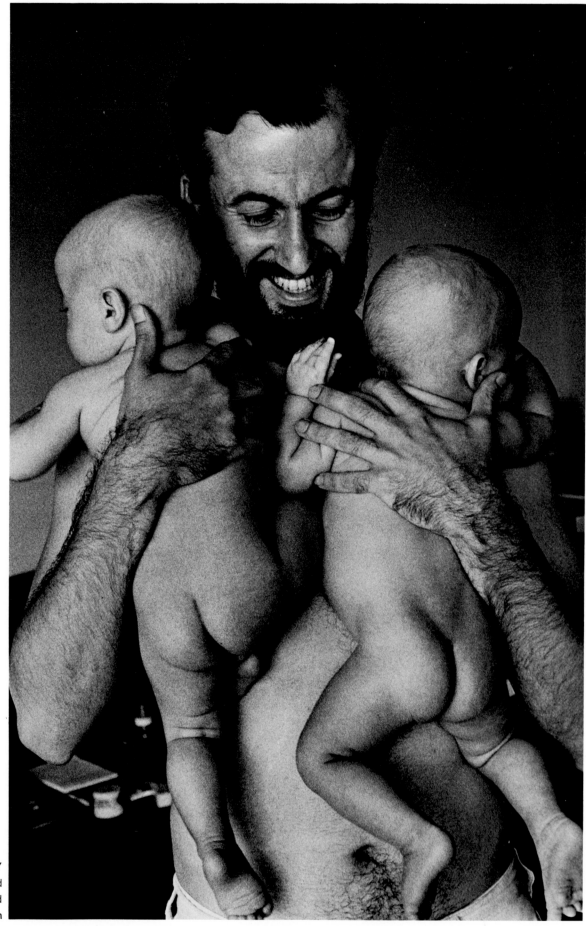

67
Chris and
Toby and Fred
Dorien Grunbaum

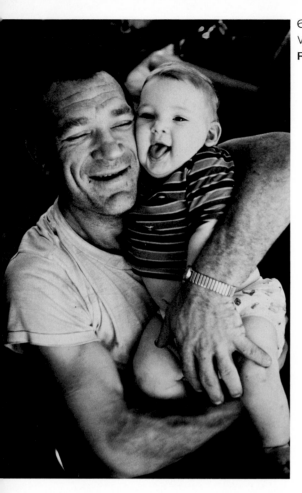

68
Walt, November 1972
Patt Blue

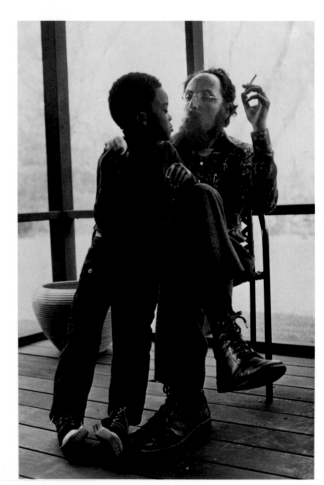

69
Mark and his Adopted Son, Ari
Sherry Suris

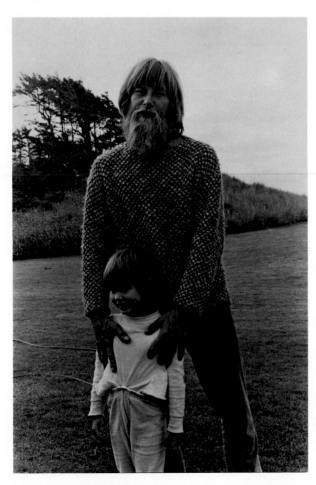

70
Father and
Daughter, Oregon
Joan Menschenfreund

71
Arthur Penn with Son Matthew
Kathryn Abbe

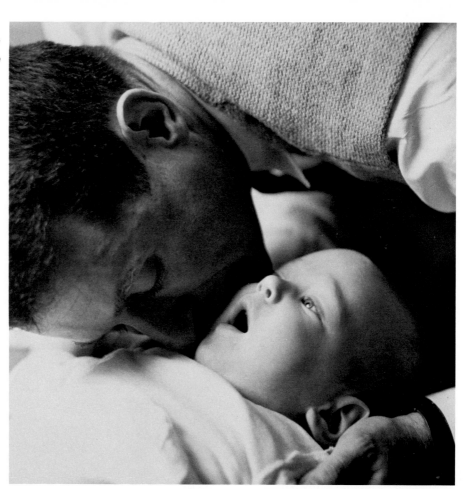

72
Family Sandwich
Fran Riche

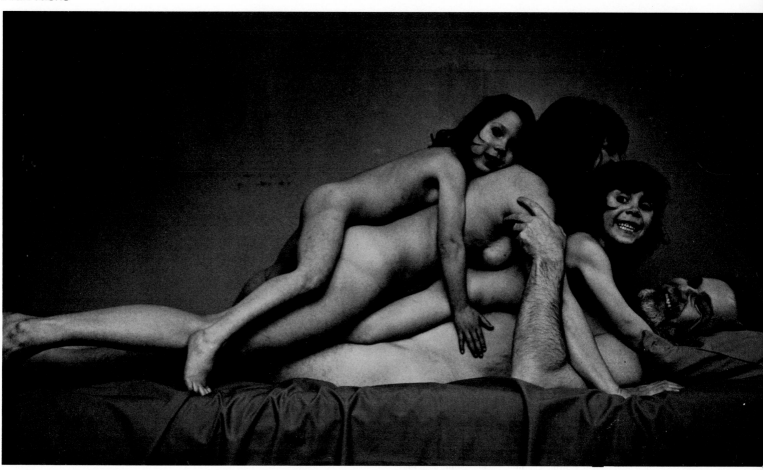

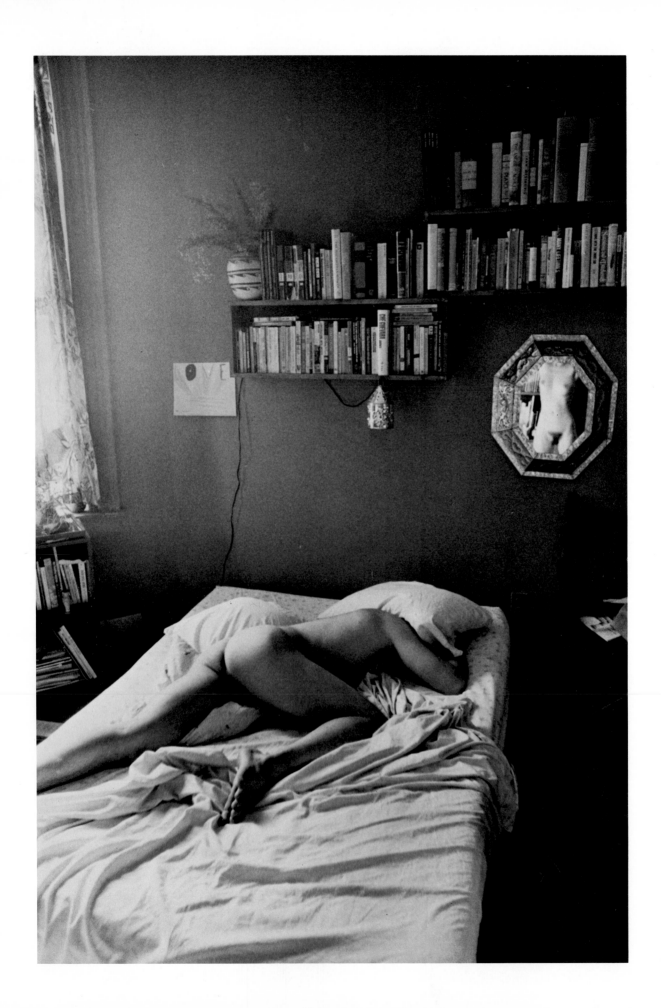

73
Untitled
Carolee Campbell

74
Joe and Zoe
L. P. Mulcahy

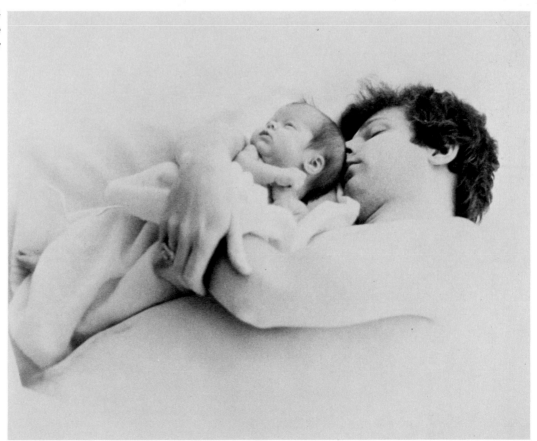

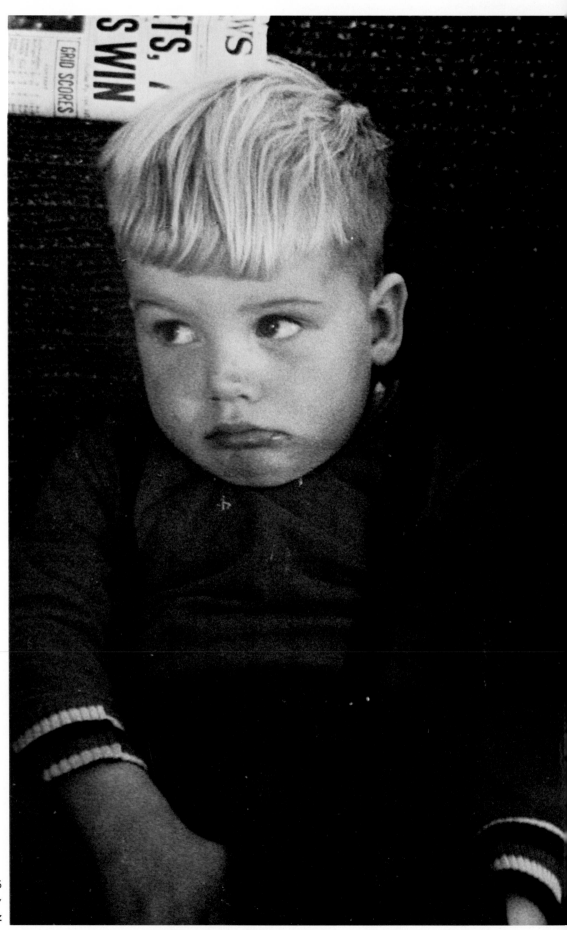

Jealousy
Suzanne Szasz

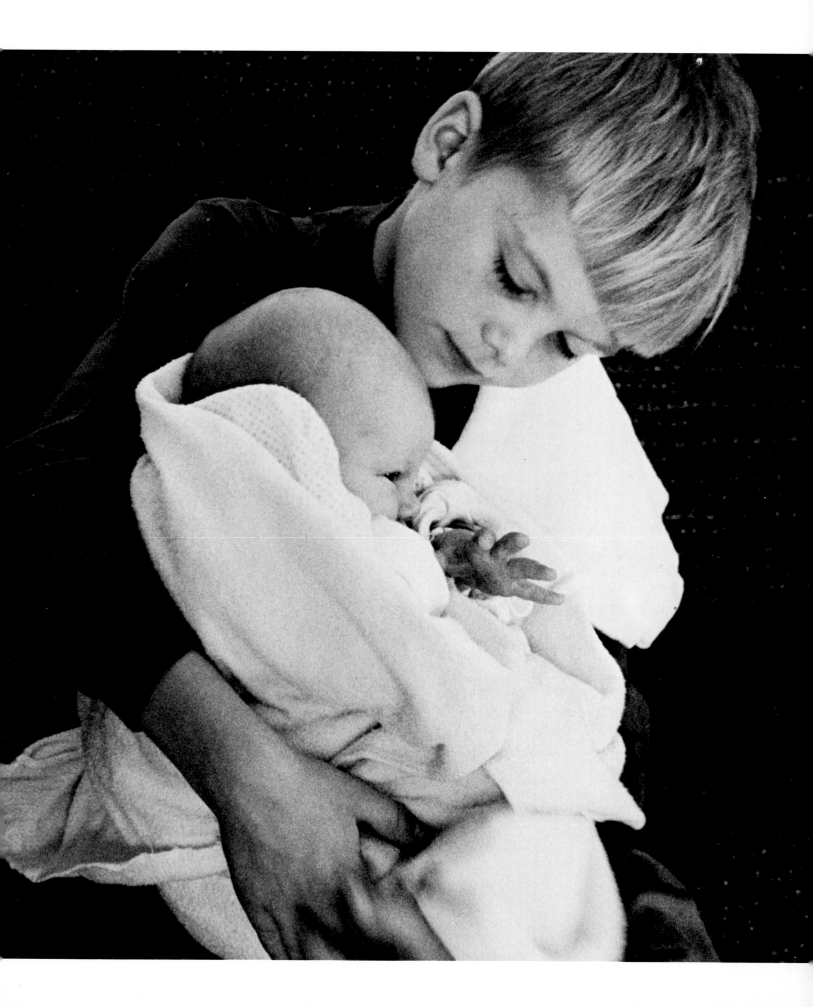

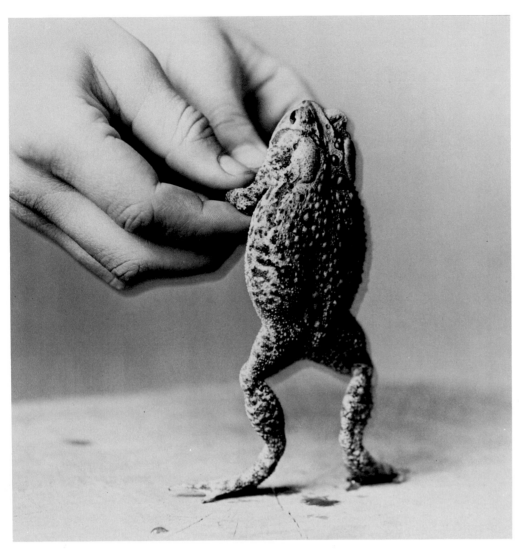

76
Doug with Toad Prince
Barbara Morgan

77
It is Snowing!
Kathryn Abbe

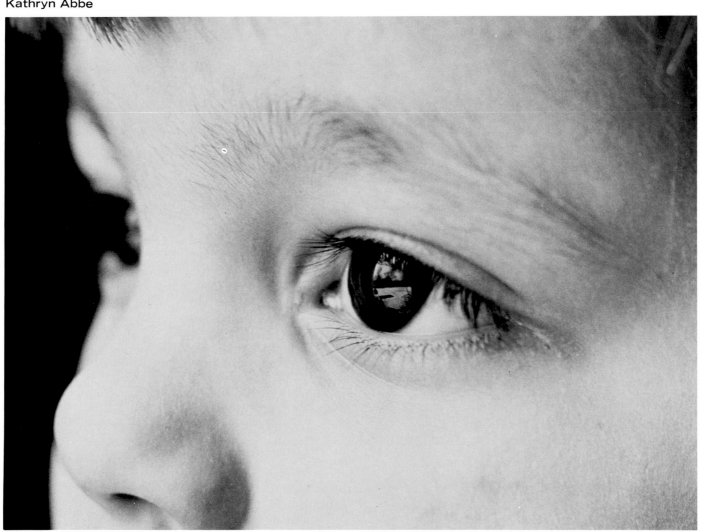

78
Untitled
Carolee Campbell

79
At Rest, Portsmouth, England
Dannielle B. Hayes

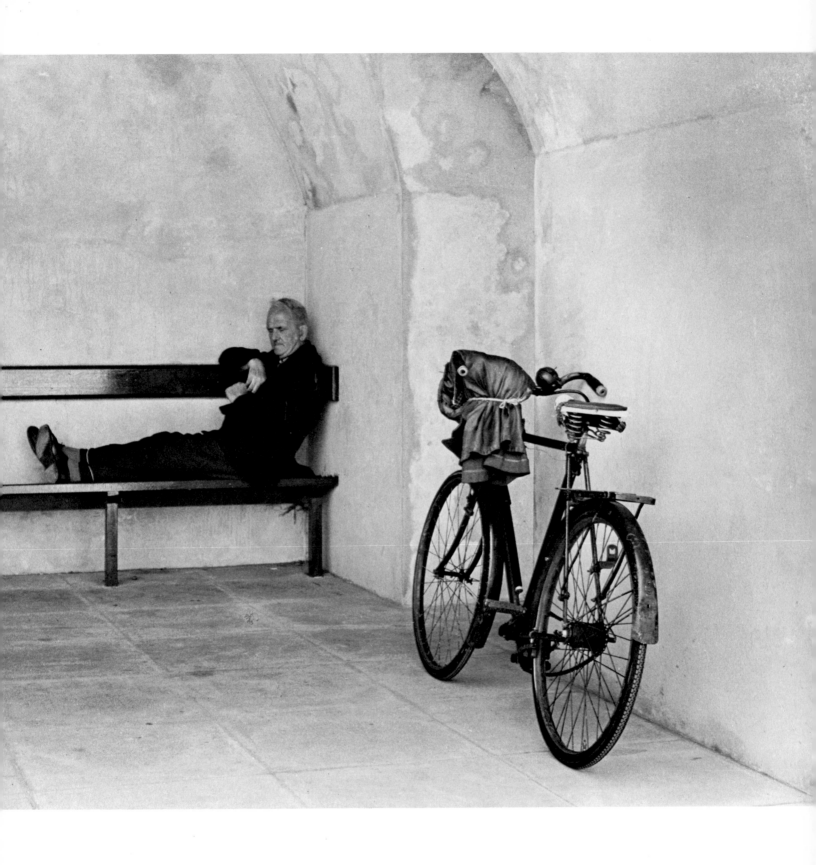

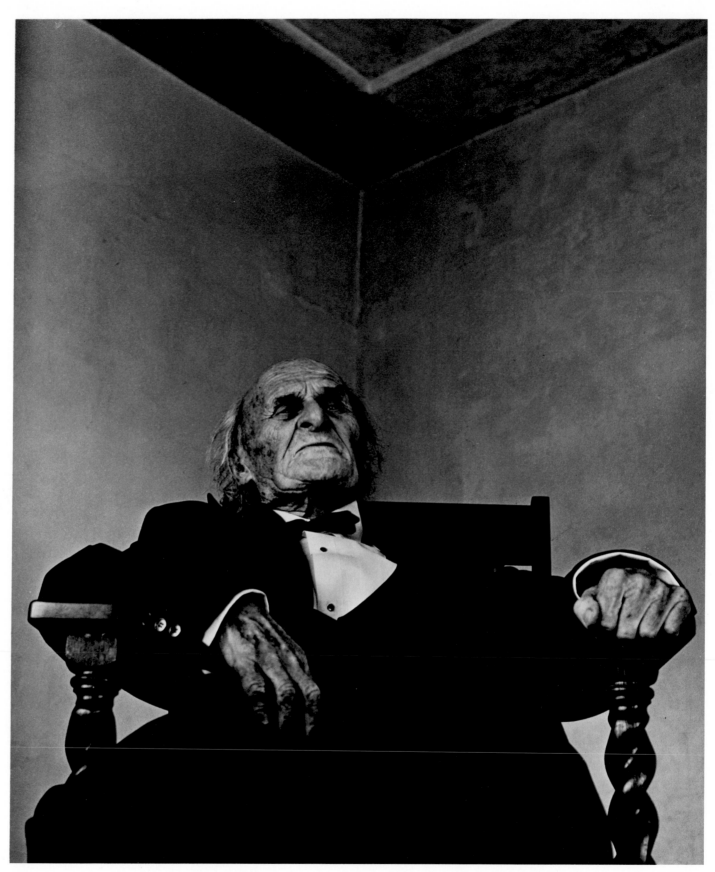

80

Valentina's Uncle, Stories of the Past

Gerda Mathan

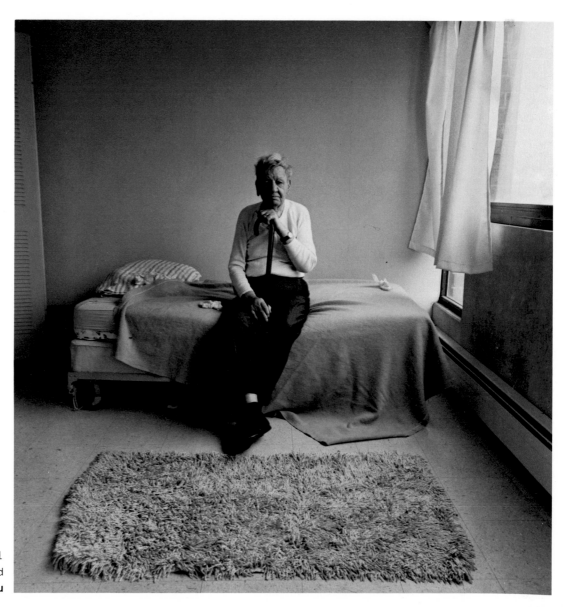

81
Untitled
M. K. Simqu

82
Oil Truck Fire
Suzanne Seed

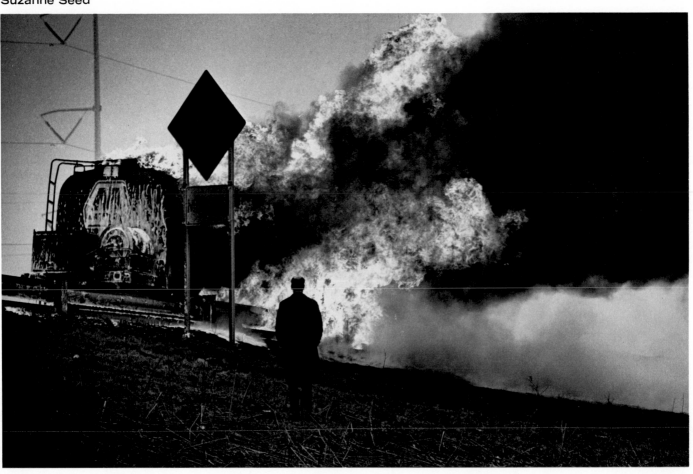

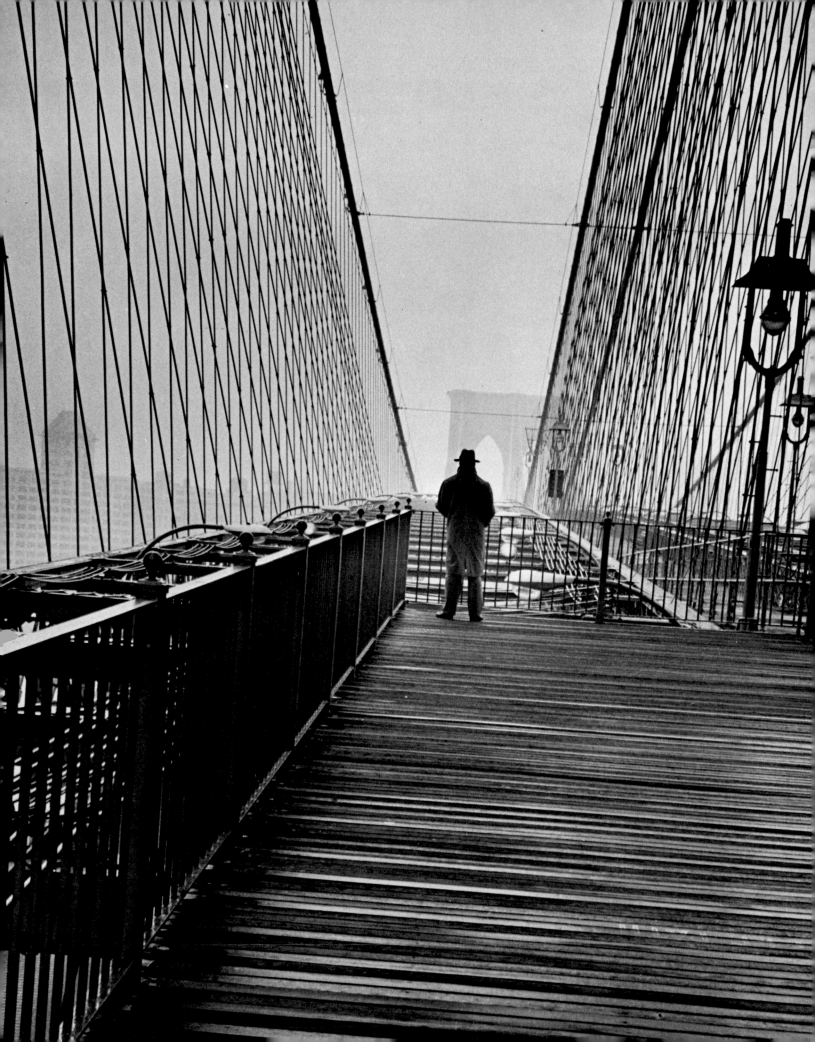

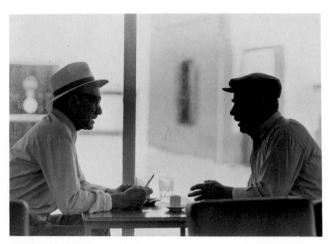

84
Taverna, Greece 1973
Rhoda Mogul

85
Untitled
Suzanne Opton

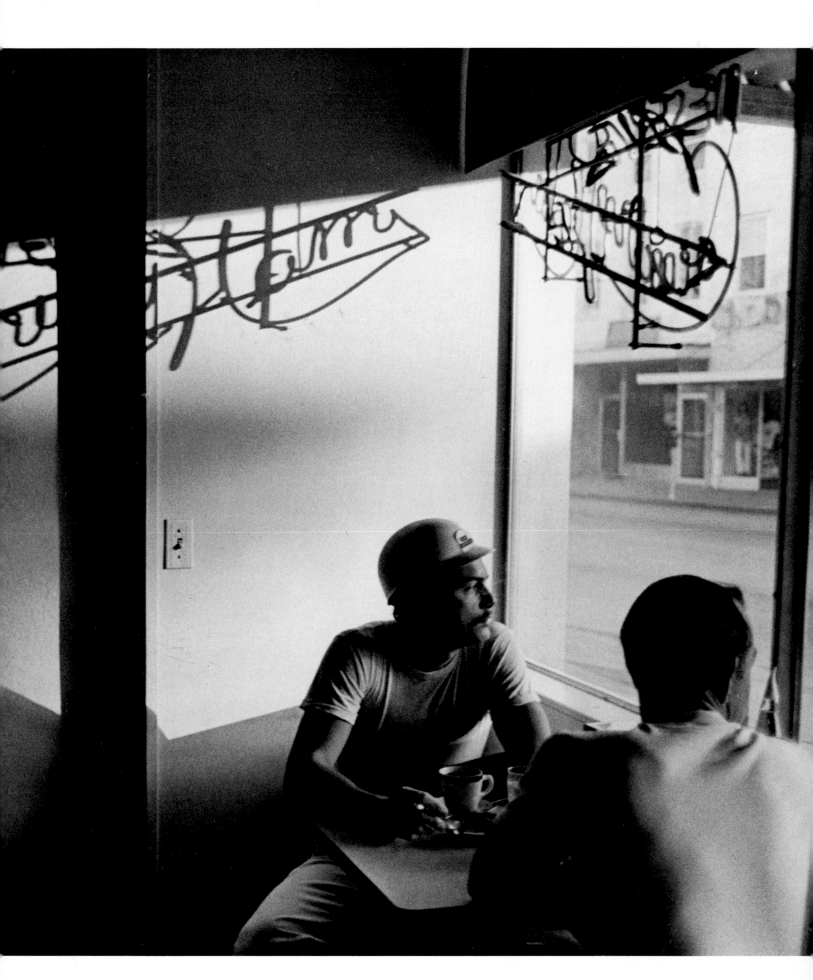

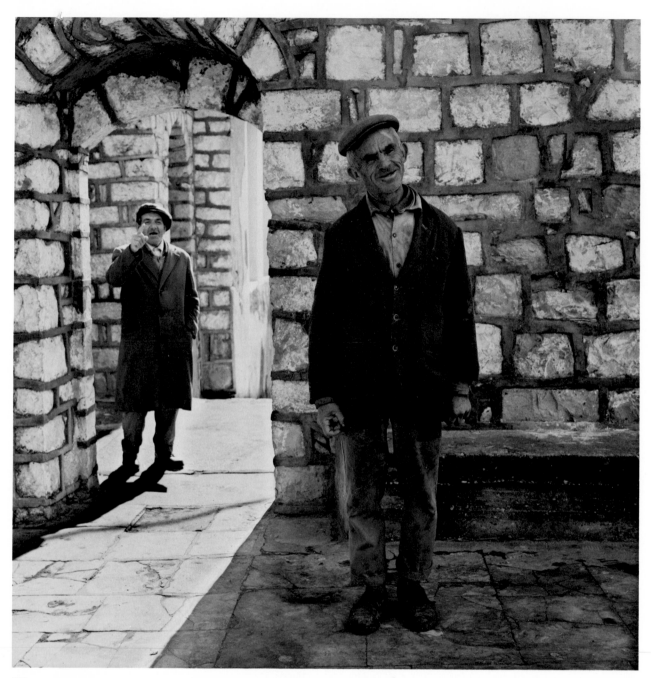

86
Safed, Israel 1972
Beth Shepherd

87
Untitled
M. K. Simqu

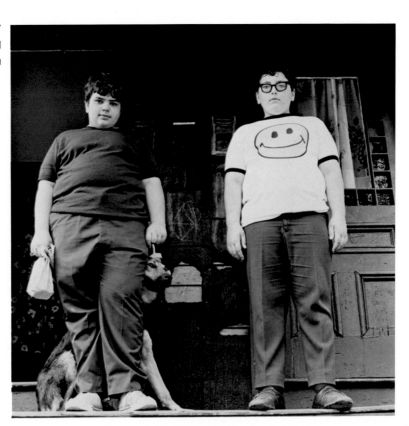

88
Hink and Jim
Suzanne Opton

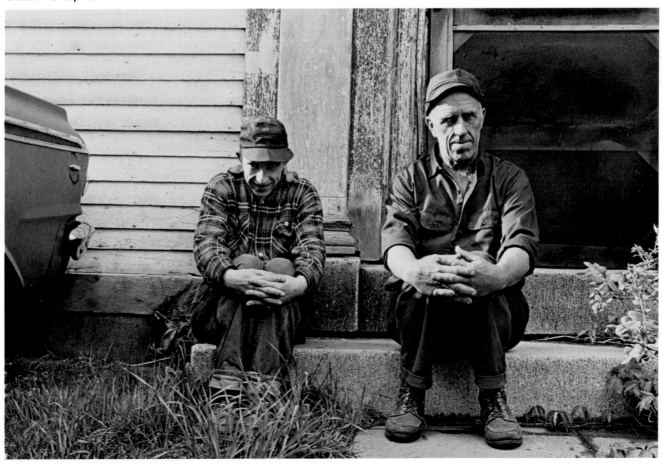

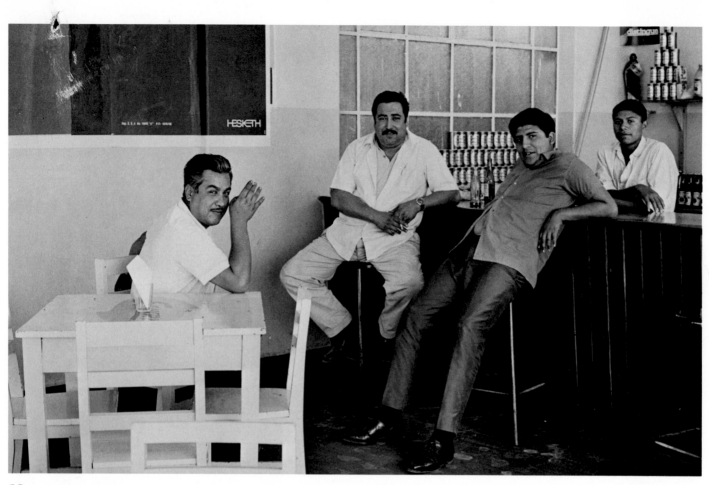

89
After the Argument, Mexico
Dannielle B. Hayes

90
Before Burial, Mexico
Dannielle B. Hayes

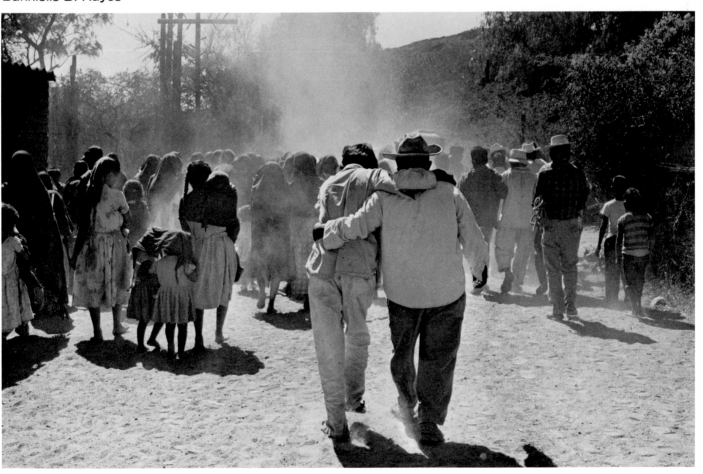

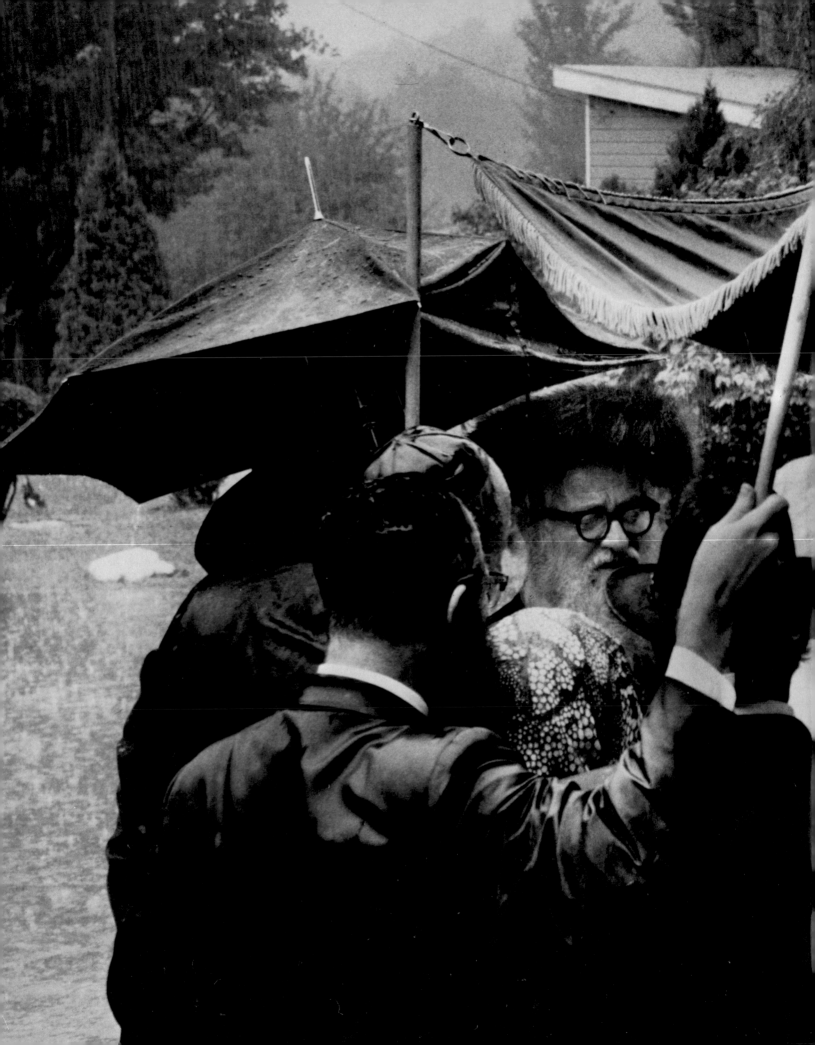

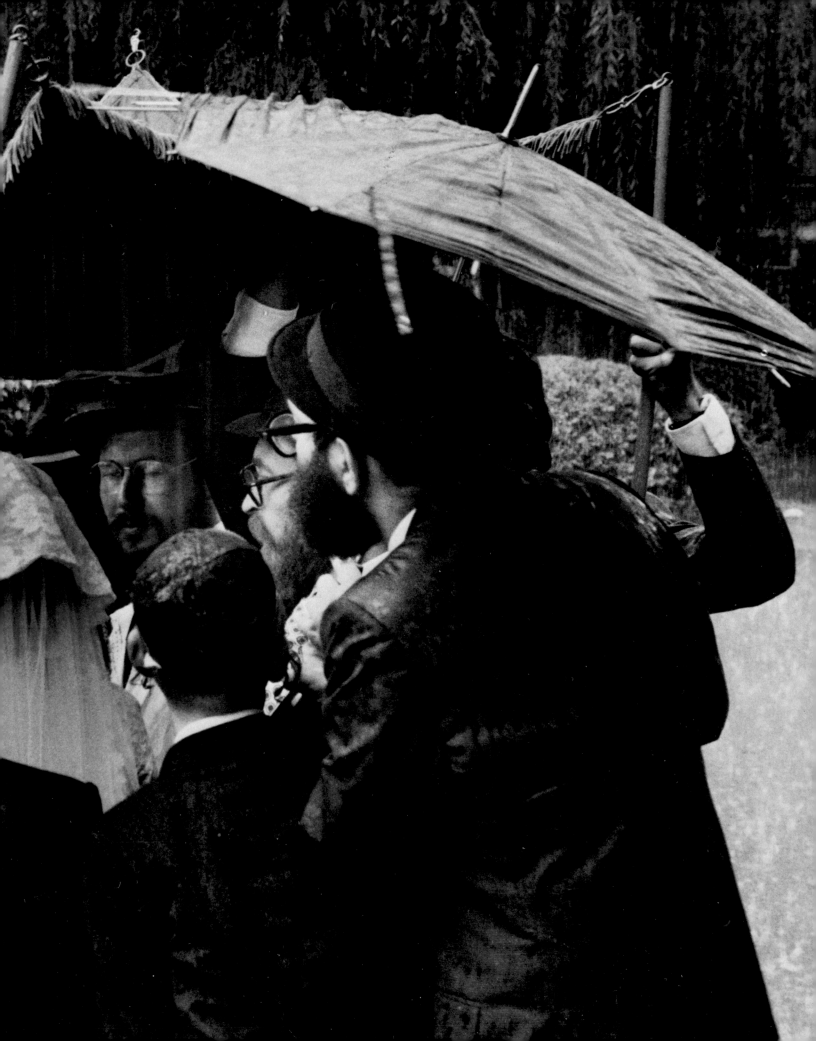

92
Wedding in Brooklyn
L. Fornasieri Gold

93
Operation Sail in Operation
Sheila O'Hara

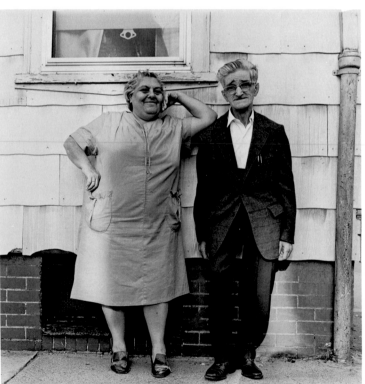

94
Untitled
M. K. Simqu

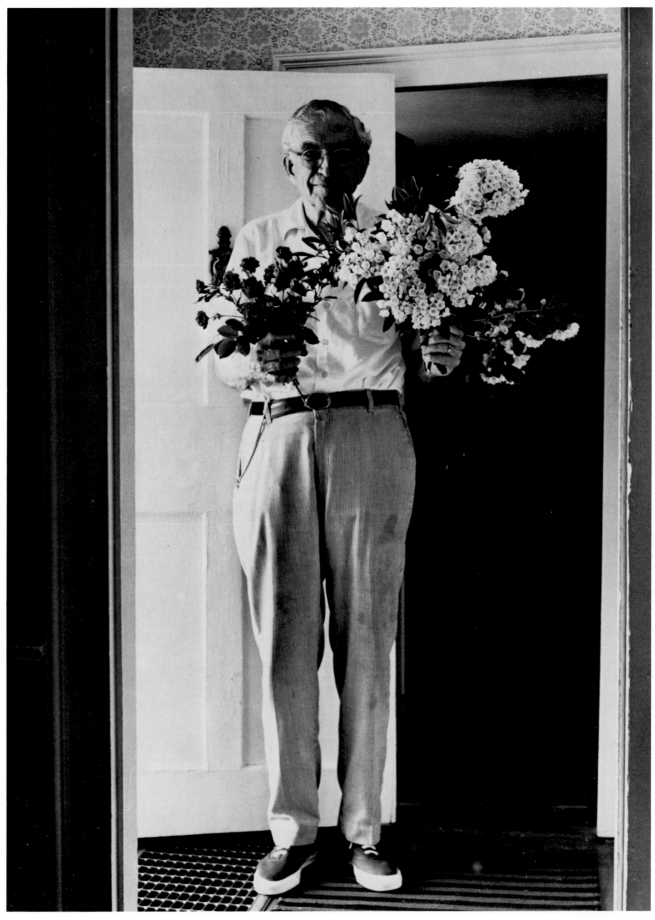

95
Nathan,
Memorial Day 1976
Nina Howell Starr

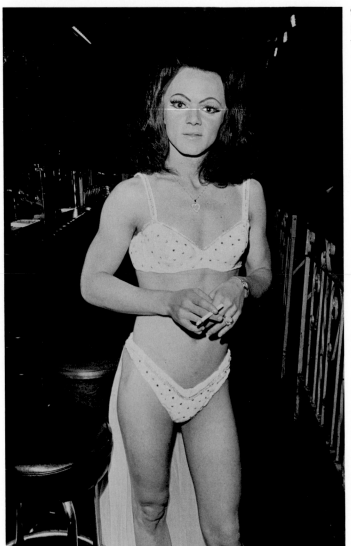

96
Mr. Bobby Brooks
Virginia Hamilton

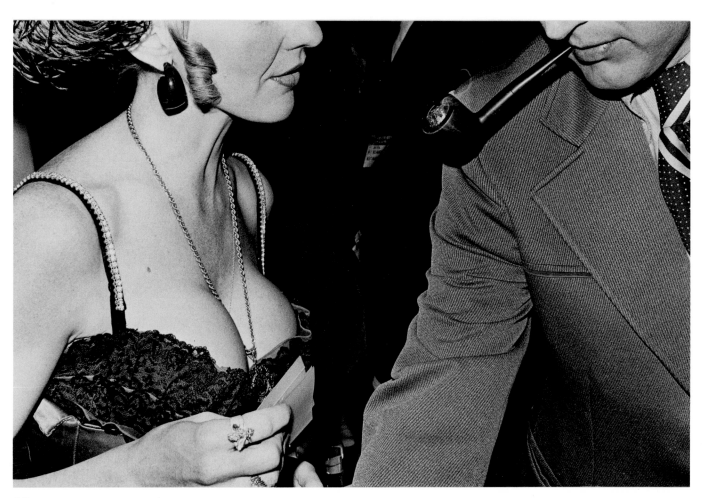

97
Untitled
Marcia Prager

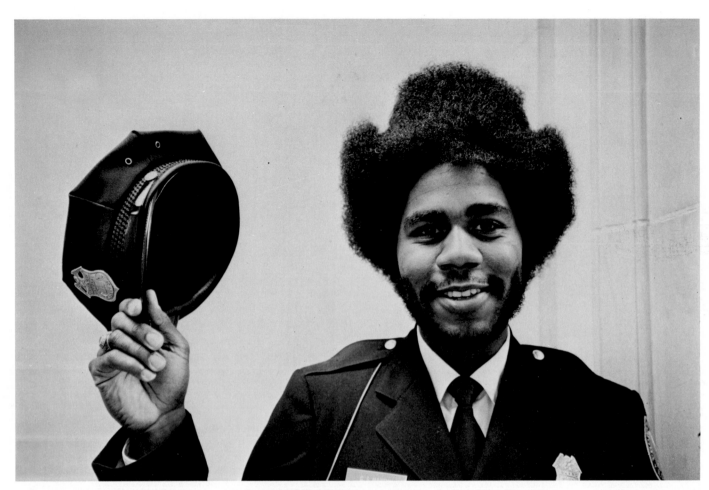

98
Untitled
Janet Nelson

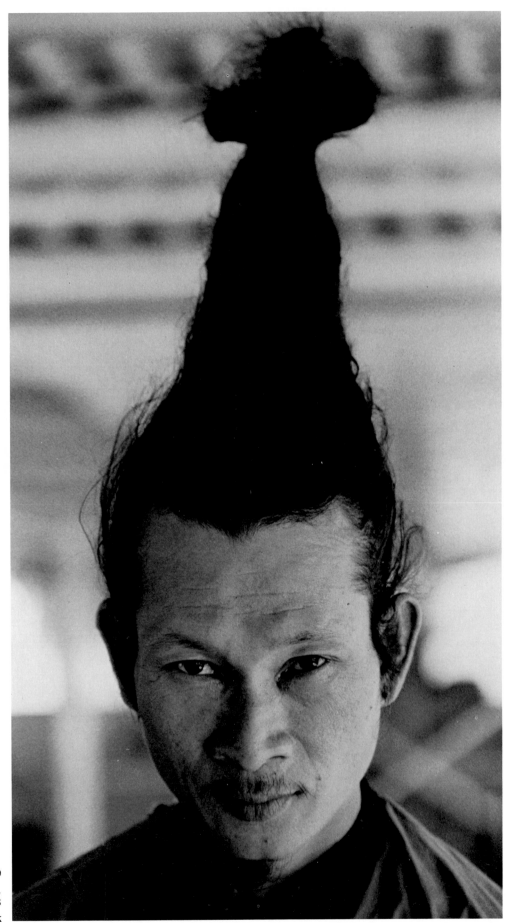

99
Coconut Monk Disciple,
Phoenix Island, Vietnam 1973
Barbara Gluck

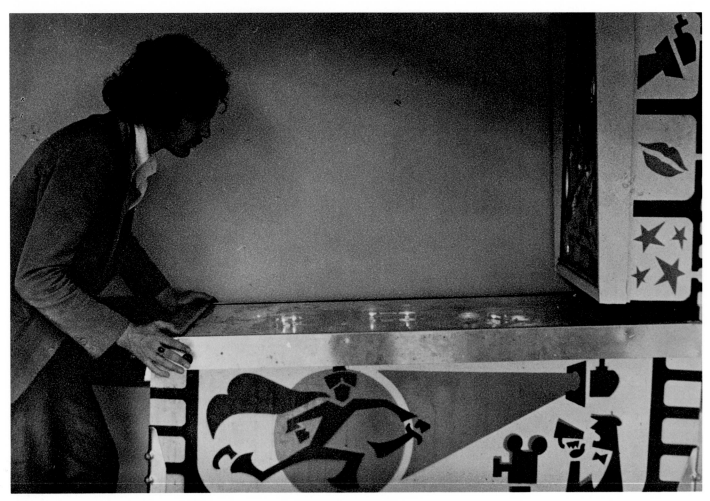

100
Man with Pinball Machine
Jill Lynne

101
An Evening with Jerry and Ted
Patricia Carroll

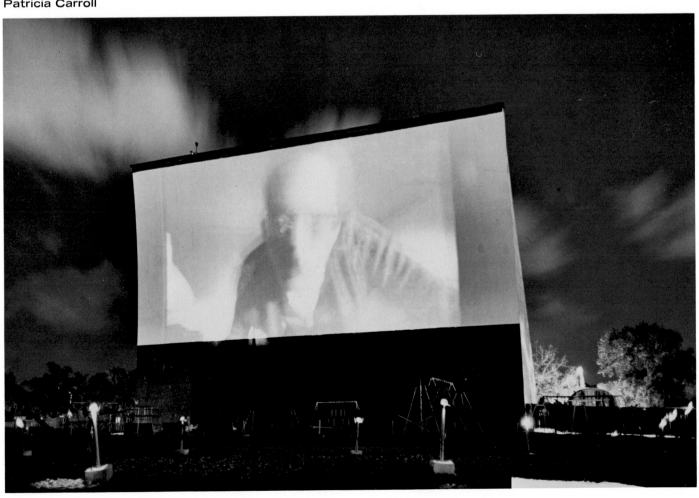

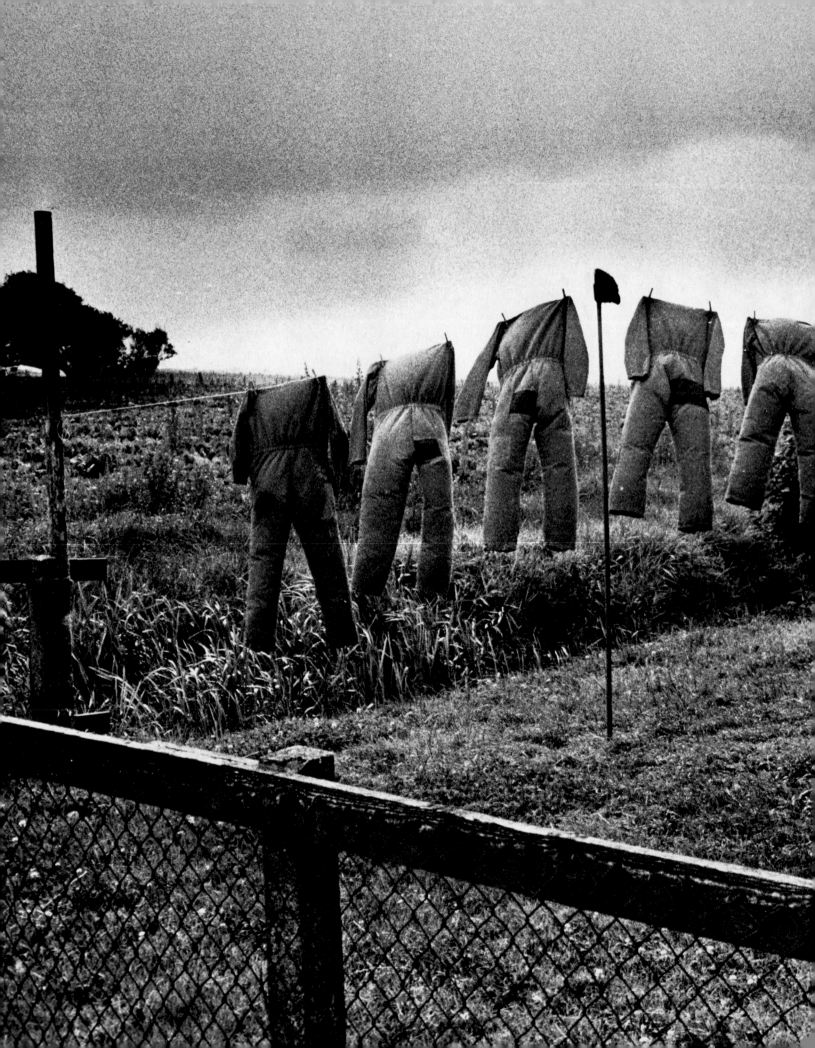

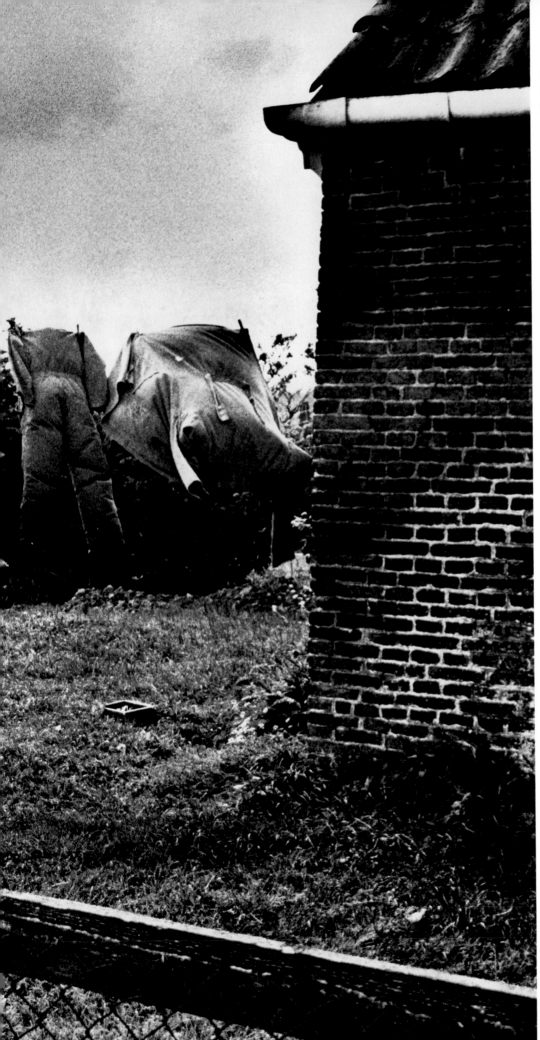

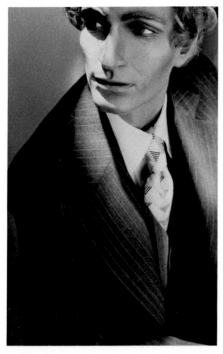

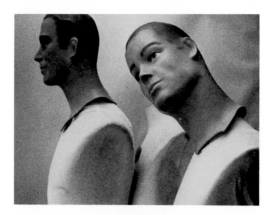

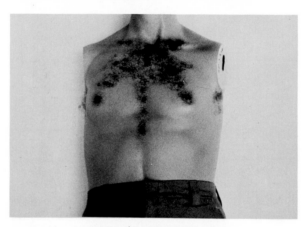

103
Bachrach, from Mannequin Series
Linda Szabo White

104
Two Heads, from Mannequin Series
Linda Szabo White

105
Chest, from Mannequin Series
Linda Szabo White

106
Feet, from Mannequin Series
Linda Szabo White

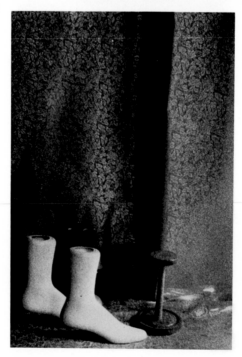

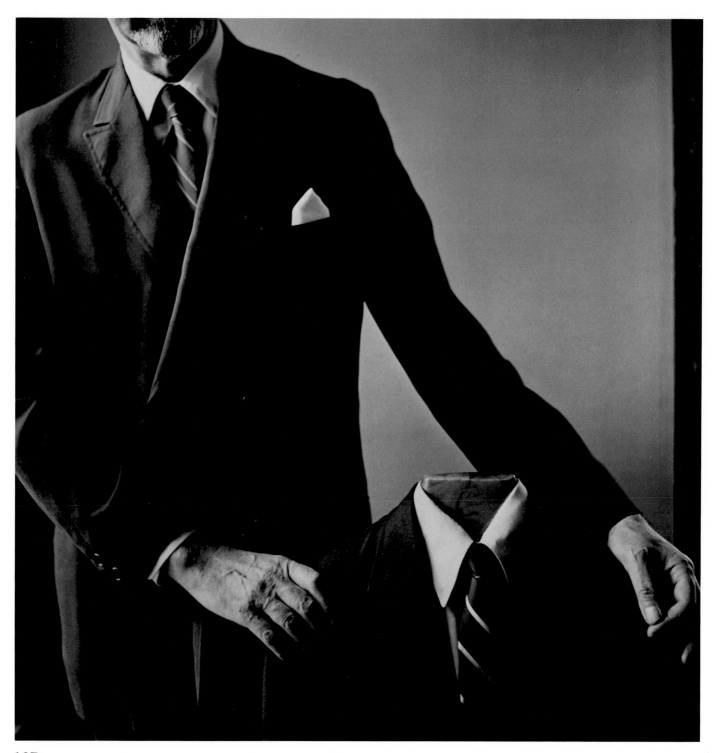

107
Valet
Minnette Lehmann

108
Passport Picture
Nina Howell Starr

109
Jesus Christ
Dawn Mitchell Tress

110
Untitled
Kathleen Larisch

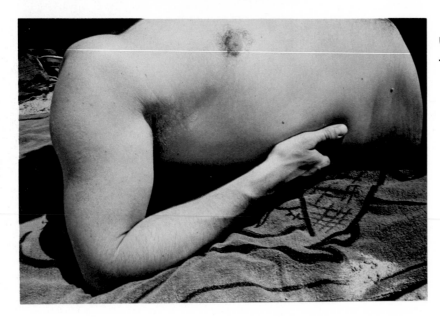

111
Untitled
Joan Liftin

112
Untitled
Holly Maxson

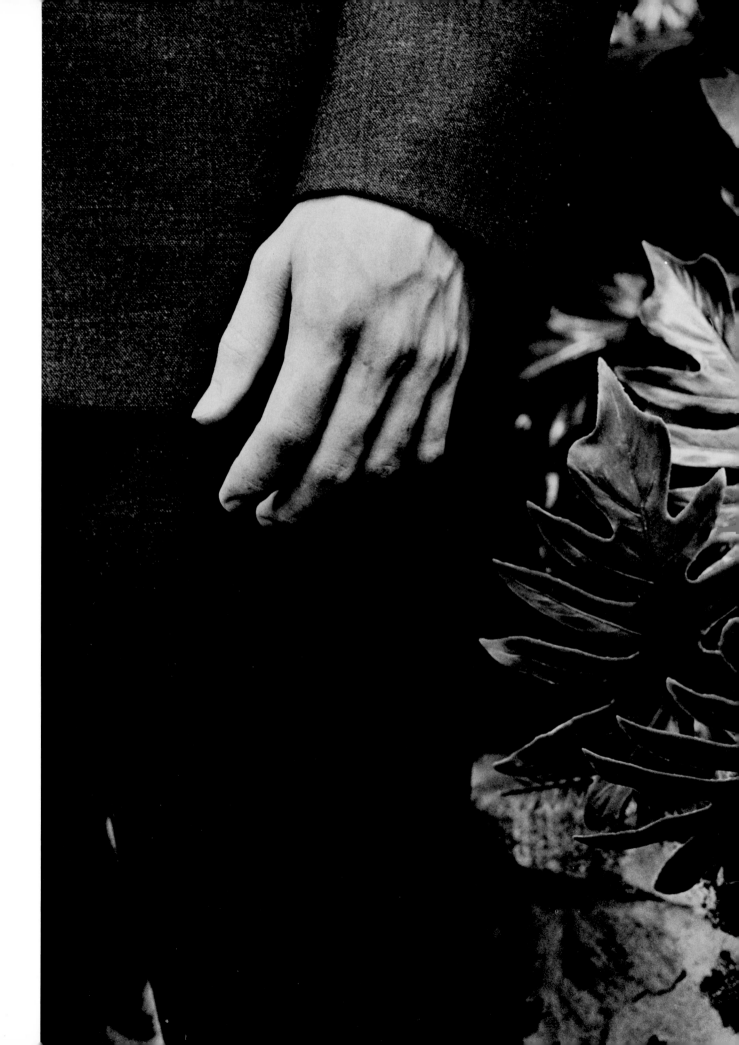

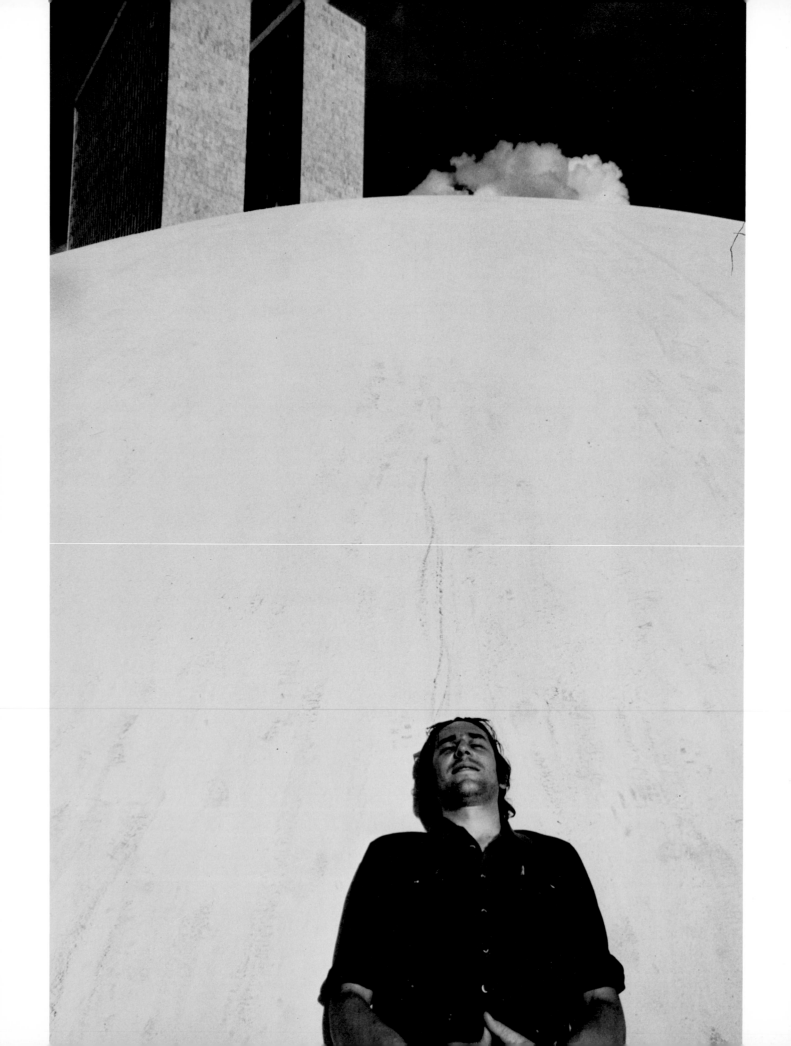

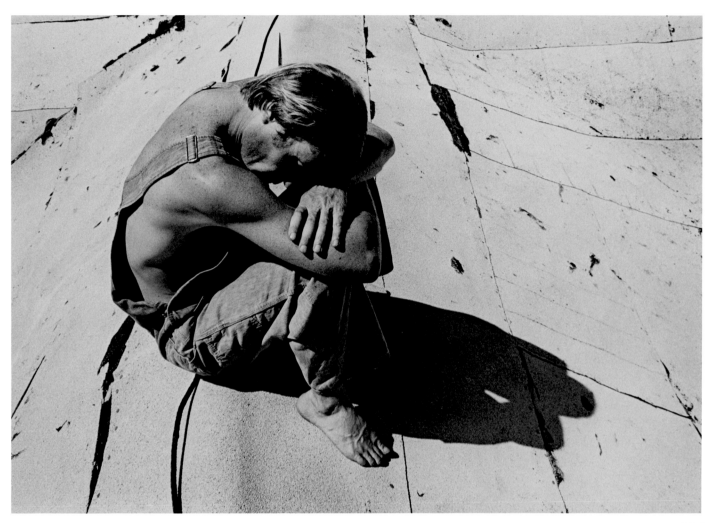

114
Jim
Ann Mandelbaum

113
Giora in Brasilia, Summer 1972
Ruth Breil

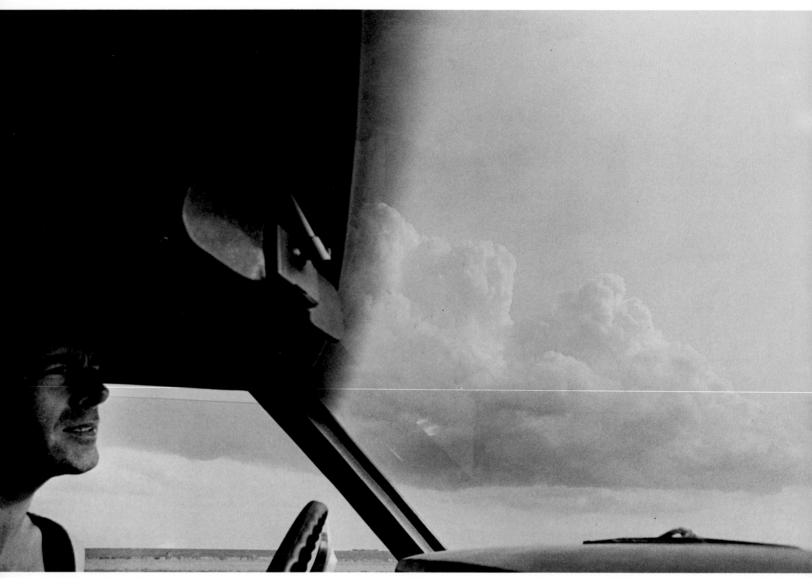

115
Untitled
Suzanne Opton

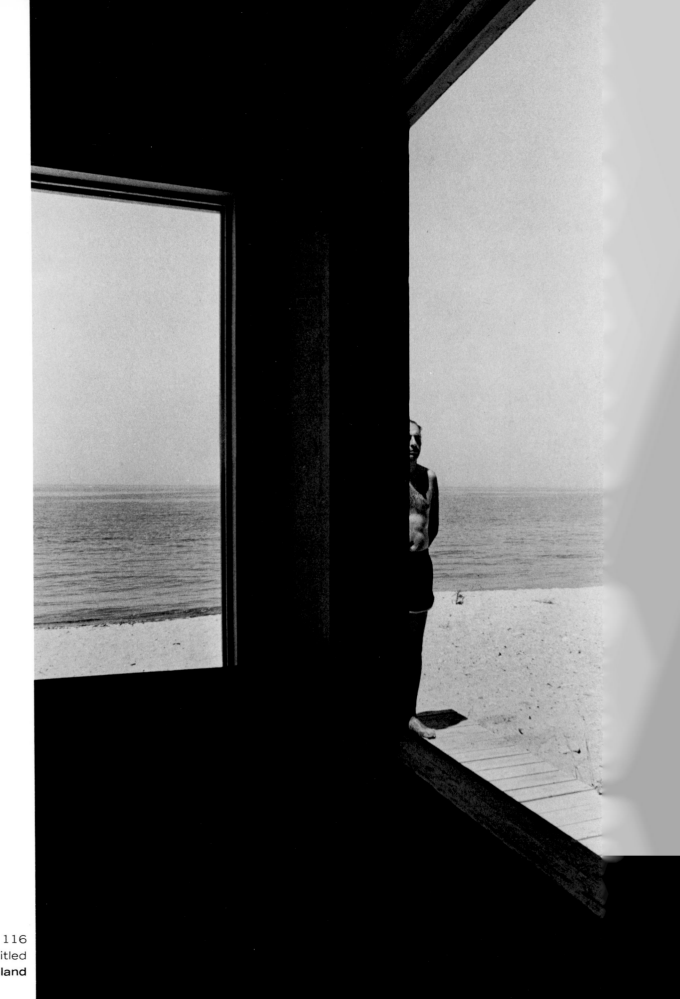

116
Untitled
Robin Holland

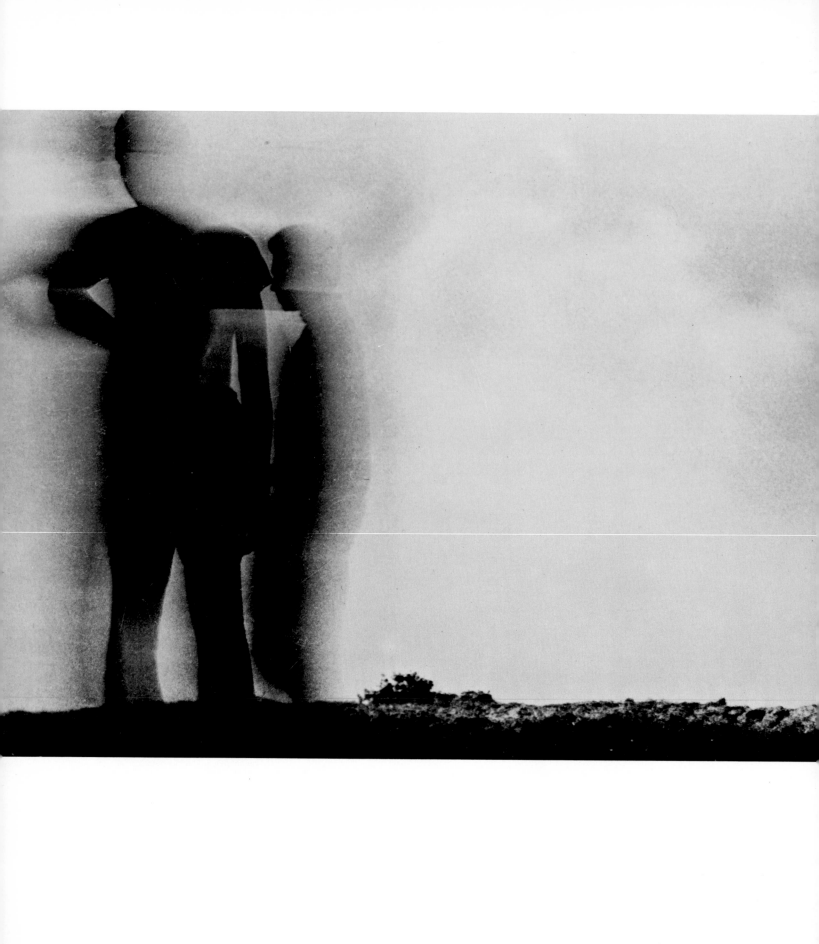

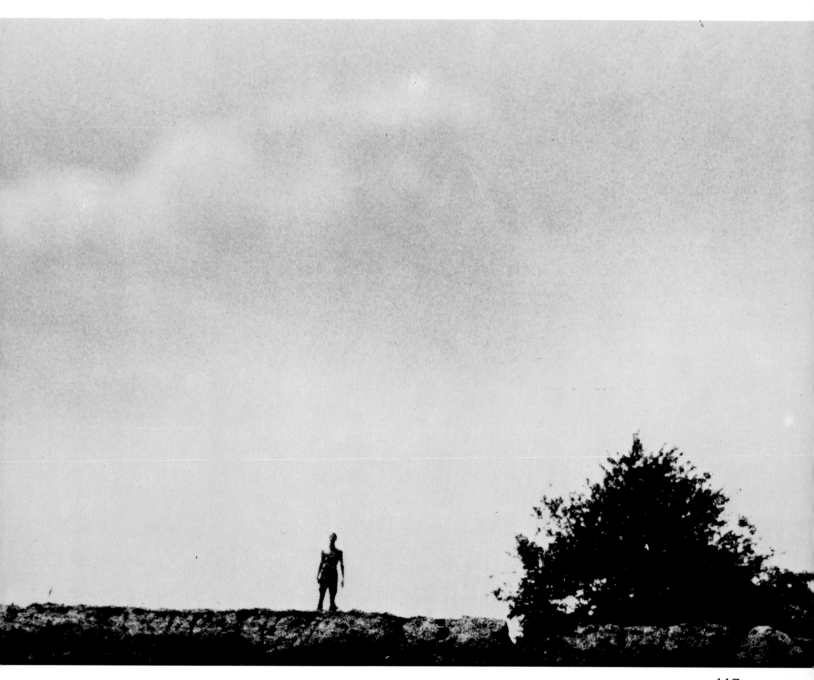

117
Untitled
Eileen K. Berger

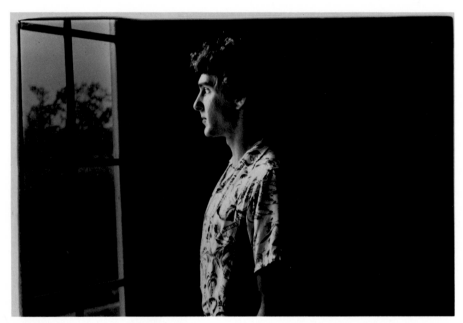

118
Michael B.
Barbara Astman

Kathryn Abbe (Jericho, N.Y.), a graduate of Pratt Institute, worked two years for *Vogue* photographer Toni Frissell, and since 1945 has had photographs published in *Vogue, McCall's,* and *Paris Match,* among others. Her work has been exhibited at the Brooklyn Museum, Metropolitan Museum, IBM Gallery, and in a European tour sponsored by the U.S. State Department. Her latest project was a color-slide/sound show entitled "On Montauk." (Plates 44, 52, 71, 77, Color Plate 4)

Arlene Alda (Leonia, N.J.), a Hunter College graduate and photojournalist, was recipient of the 1974 Chicago Graphics Award for Excellence in the Communicating Arts for her photo essay entitled "Allison's Tonsillectomy." Her photos and photo essays have been published in *The New York Times, New York, Pageant, Today's Health,* and *Ms.,* among other journals. She has shown at Modernage, Soho Photo, and Fashion Institute in New York, and the Tenafly Art Center and Bergen Community Museum in New Jersey. (Plate 16)

Mary Ellen Andrews (New York, N.Y.) has had one-woman exhibitions at Nikon House, Soho Photo Gallery, Queens College, and the Graphics Studio Gallery of MacDowell Colony, New Hampshire, where she was on fellowships from 1973 to 1976. Ms. Andrews has been represented in numerous group shows, including "Breadth of Vision" and "Woman Photographs Man," and published in *Aperture* and *Camera 35.* (Plates 54, 55, 56)

Fran Antmann (New York, N.Y.), a graduate of Bennington College, was an art therapist before 1973, when she traveled with and photographed a small itinerant southern circus. She recently photographed Nubian life in Egypt, and is currently an instructor at Fordham University and Touro College. (Plates 14, 15)

Barbara Astman (Toronto, Ont.), known for her experimental imagery, has exhibited xerography and photographic constructions in many group and one-woman shows in the United States and Canada. She has received grants from the Canada Council and the Ontario Arts Council for her work, and is represented by the Sable-Castelli Gallery in Toronto, Ontario.

Currently, Ms. Astman teaches at the Ontario College of Art. (Plate 118)

Jeannie Baubion-Mackler (Scarsdale, N.Y.) was born in France and has been a freelance photographer since the early 1970s. Her work has been exhibited both in the United States and France where she taught at the International Festival of Photography, Arles, in 1973 and 1976. (Plate 19)

Eileen K. Berger (Wyndmoor, Penn.) has taught photography at the Tyler School of Art, Philadelphia College of Art, and Bucks County Community College, and is currently at Moore College in Philadelphia. She originated an experimental workshop on "Women in Photography" and exhibited her photographs at the Museum of Contemporary Crafts, the Philadelphia Museum of Art, Boston University, Berkeley University Art Museum, and the Soho Photo Gallery in New York. Her work has been published in *Bombay Duck,* a California publication, and in the *Women's Yellow Pages.* (Plate 117)

Patt Blue (New York, N.Y.), a graduate of SUNY at Stony Brook, is a freelance photographer who created and directed a television commercial on alcoholism, and has exhibited in numerous group shows. Her documentary work on "The Family" was exhibited this year at Photokina in Milan, Italy, and she is currently on the staff and faculty of the International Center of Photography. (Plates 48, 57, 58, 68)

Ruth Breil (New York, N.Y.) is a 1976-77 CAPS Fellowship recipient, and has exhibited her work in the United States and Brazil. She is associate editor for *Photograph* magazine and teaches photography in the Artists-in-the-Schools program, New York City. Her work has been published in *The New York Times, Fotoptica,* and *Aperture,* and is in the collections of M.I.T. and Bibliothèque Nationale. (Plates 21, 22, 113)

Carolee Campbell (New York, N.Y.) is a seasoned actress as well as photographer. Since her first solo exhibit at the Crossroads Gallery in 1976, Ms. Campbell's photographic achievements have been shown at the Museum of Natural History, National Art Museum of Sport, and Soho Photo Foundation. Of late, she formed a

film production company with her husband, and is preparing two books of her photographs. (Plates 33, 37, 38, 73, 78)

Bobbi Carrey (Cambridge, Mass.), a former faculty member in the Visual Studies Department at Harvard University, is now Assistant Professor at the University of Iowa School of Art. She coordinated photographic and written materials in the estate of Edward Steichen, was assistant to Walker Evans, and has conducted numerous lectures and workshops. Exhibited and published widely, her work is in the collections of the Museum of Modern Art and the Bibliothèque Nationale. (Plate 36)

Patricia Carroll (Chicago, Ill.), a graduate of the University of Illinois and the Illinois Institute of Technology, is very active as instructor, lecturer, and exhibitor in the photographic field. Her work has been in numerous group and one-woman shows throughout the country, and is in the collections of the Library of Congress, Krannert Art Museum, and the Smithsonian Institution. Recipient of a faculty research grant from Pennsylvania State University, Ms. Carroll is currently teaching at Columbia and Triton Colleges in Illinois. (Plate 101)

Patricia Caulfield worked for *Modern Photography* for several years, but retired from her post as executive editor in 1967 to devote all of her time to nature photography and conservation. Her photographs have appeared in many periodicals including *Audubon* and *Natural History,* and currently the bulk of her work is for *The National Geographic.* She is the author of two guidebooks, *The Guide to Kodachrome Films* and *The Beginner's Guide to Better Pictures,* both published by Amphoto. A book of her nature photographs, *Everglades,* was published by The Sierra Club in 1970. (Plate 51)

Susan Cook, a graduate of Dana Hall, Briarcliff, and the University of London, is known for her photographs of theater and dance. Her work has been published in many periodicals, and she is the author of *In a Rehearsal Room,* a study of Ivan Nagy and Cynthia Gregory. (Plate 13)

Flo Fox (New York, N.Y.), beginning a serious involvement with photography in

1972, has since exhibited in the prestigious Photographers' Gallery in London and at the International Center of Photography. Her work has been published in *35 MM Photography* magazine and in the book *Ecstasy*. (Plate 30)

Jane Courtney Frisse (Syracuse, N.Y.) is a freelance commercial photographer who studied with Aaron Siskind. She has exhibited at the Everson Museum of Art, and her work will be included in the books *Cazenovia, An Upland Community* and *Modern Ceramic Art*, both to be published this year. (Plates 5, 6)

Barbara Gluck (Santa Fe, New Mexico), a documentary and journalistic photographer, divides her time between Santa Fe and Los Angeles. Ms. Gluck spent almost four years in Indochina photographing the war, and her photographs have been exhibited and published widely. She has lectured at Yale, I.C.P., Women's Interart Center, and the New School, and was one of the coordinators of "Breadth of Vision." (Plates 29, 45, 99. Color Plate 8)

L. Fornasieri Gold (Brooklyn, N.Y.) is a New York photographer who studied with Ken Heyman, Garry Winogrand, and Lisette Model. She had a one-woman show in Wellesley, Massachusetts, and was represented in the exhibit "Breadth of Vision: Portfolios of Women Photographers" at the Fashion Institute of Technology in New York City. (Plates 24, 92)

Beryl Goldberg (New York, N.Y.) is a freelance photographer and writer, whose work has appeared in many publications including *Africa Report, Popular Photography*, and *Natural History* magazine. She has exhibited her photographs in several group and one-woman shows, and was recently given a Purchase Award from the Portland Museum of Art in Maine. (Plate 20)

Dorien Grunbaum (New York, N.Y.) is a freelance photographer who has shown her work at the Soho and Crossroads Galleries, and at the Fashion Institute of Technology. She is a member of the photography collective, Other Eyes. (Plates 66, 67, 116)

Jeanne Hamilton (New York, N.Y.) specializes in still-life photography and has

had several shows of both her color and black-and-white compositions. She has photographed for two photo-realist painters, and she also uses her large format camera to capture the passing New York scene. (Plate 2)

Virginia Hamilton (New York, N.Y.), while studying with Lisette Model at the New School, was also staff photographer at the *Manhattan Tribune* and assistant to Charles Gatewood. Ms. Hamilton has exhibited her work at the Museum of the City of New York, Neikrug Gallery, the Nadar Gallery in Pisa, Italy, and in a solo show, "Mardi Gras," at the Third Eye Gallery. A five-year documentation of the New Orleans Mardi Gras is in progress. (Plate 96)

Diane Harrington (New York, N.Y.), instructor and program advisor of Educational Media Graduate Program at Lehman College (CUNY), is also a doctoral candidate at Teachers College, Columbia University, where she combines interests in photography, education, and visual anthropology. Her work was exhibited in "Breadth of Vision" and "Woman Photographs Man." A project with several other women photographers entitled "New York Women at Work" is her most recent involvement. (Plate 46)

Dannielle B. Hayes (New York, N.Y.), a graduate of Cooper Union, is a freelance photographer, illustrator, and journalist. Her photographs have been exhibited in group shows in the New York area including the Floating Foundation of Photography, 1976, and her work is in private collections in the United States and Canada. Elected photography chairwoman for the International Women's Arts Festival in 1975–76, she conceived and directed "Woman Photographs Man" and is the author/editor of *Women Photograph Men*. (Plates 79, 89, 90. Color Plate 2)

Diana Mara Henry (New York, N.Y.) began photographing ten years ago for her college newspaper, *The Harvard Crimson*. A specialist in political photography, she was awarded a *Newsweek*-Konica "Focus on Politics" prize in 1972, and has contributed images to such magazines as *More, Popular Photography, Interview*, and *Time*. Ms. Henry organized the Community Workshop Program at the International Center of Photography,

and recently placed a collection of her photographs at the Schlesinger Library Collection, Radcliffe College, Cambridge, Massachusetts. (Plates 23, 25, 27)

Robin Holland (New York, N.Y.) received a B.A. in creative writing and literature from Harpur College (SUNY, Binghamton). She has freelanced as writer and photographer for *The Village Voice* Centerfold, and has exhibited her work in several group shows including "Identities" at the Third Eye Gallery, of which she is a member. (Plate 116)

Sardi Klein (Brooklyn, N.Y.) is staff photographer for *Free Enterprise Magazine* and still finds time to teach at the School of Visual Arts and to women inmates at Bedford Hills Correctional Facility under the Floating Foundation of Photography program. (Plate 3)

Kathleen Larisch (Hayward, Calif.) earned an MFA from the California College of Arts and Crafts, Oakland, where she has also taught textile printing. She has exhibited widely in California as well as in New York, namely at the Women's Interart Center and F.I.T. in "Breadth of Vision." Currently Ms. Larisch instructs at Pacific Basin Textile Arts, Berkeley. (Plate 110)

Minnette Lehmann (San Francisco, Calif.) received an MFA in photography from San Francisco Art Institute, and has taught the history of photography at San Francisco State University. In 1976, she was awarded a grant from the National Endowment for the Arts and presently she teaches photographic technique and esthetics at the University of California Extension. (Plate 107)

Joan Liftin (New York, N.Y.) is director of Magnum Photo Library, and has had portfolios of her work published in *Zoom, Creative Camera*, and *Modern Photography Annual*. Ms. Liftin's photographs have been seen in solo exhibits at the Photography Place, the Midtown Y Gallery, Raffi Photo Gallery, and Soho Photo, in addition to being part of a European touring exhibit featuring eight American women photographers. (Plate 111)

Jill Lynne (New York, N.Y.), an artist and photographer, teaches at the International Center of Photography, the New

School, N.Y.U., and Nassau Community College in their photography programs. Her recent work using 3M and Xerox processes, was exhibited at I.C.P. and published in *Popular Photography*. Ms. Lynne was one of the coordinators of "Breadth of Vision." (Plate 100)

Ann Mandelbaum (Brooklyn, N.Y.) received an M.A. in Media Studies from Antioch and has since taught photography at the New School for Social Research, College of New Rochelle, Calhoun School, New York City, and Artists-in-the-Schools Program, New York City. She is a grant recipient for Historical Photo Exhibit, New York State Council on the Arts, and America the Beautiful Fund, and is currently working on a book entitled *Films Kids Like, II*. (Plates 39, 114)

Mary Ellen Mark (New York, N.Y.), is a Magnum photographer whose coverage of worldwide events has been seen frequently in major exhibitions and publications. A book of her photographs, *Passport*, was published in 1974, and this year she was the recipient of grants from the National Endowment and the New York State Council on the Arts, CAPS. (Plate 63)

Gerda S. Mathan (Berkeley, Calif.), emigrated with her parents to California from Germany in 1938. She taught in the life sciences for many years before turning to photography, and since 1969 has had eight one-woman exhibits. Her work has been published in *Ms.* magazine and *California Living* magazine, and is presently at work on a photography book about an old man. (Plate 80)

Holly Maxson (Hartsville, Penn.), has been photographing for the past three years. Her images were seen in "Breadth of Vision" and "Woman Photographs Man" in New York City, and in "Women's Work", Millersville, Penn. Recently, they placed first in the photographic categories of two Pennsylvania Arts Festivals. (Plate 112)

Frances McLaughlin-Gill (New York, N.Y.) is a freelance photographer and twin of photographer Kathryn Abbe. She began her career in 1943 as staff photographer for Condé Nast Publications, and her work has appeared in *Vogue, Glamour, McCall's,* and many other major publica-

tions. Exhibited widely in shows including "Photography in the Fine Arts I and II" (1962, 1964, Metropolitan Museum) and at the Musée Française de la Photographie, France, 1976, she also teaches a photo seminar at the School of Visual Arts. A book of her photographs, *Face Talk, Hand Talk, Body Talk* was published this year, and another book is in progress. (Plates 9, 10, 53)

Joan Menschenfreund (New York, N.Y.) is a freelance photo editor and art director for publishers of educational books and filmstrips. A graduate of New York State University in Buffalo, she also does editorial layouts for *Newsweek*, and was artist in residence at Cummington Community in the Arts, Massachusetts, this year. (Plate 70)

Linda Joan Miller (Port Jefferson, N.Y.), a former teacher in the public school system, studied photography at the New School for Social Research, and is currently pursuing medical studies at the State University of New York in Stony Brook. (Plate 50)

Dawn Mitchell Tress (Scarborough, N.Y.) exhibited twelve years of work in her first one-woman show at the Soho Photo Gallery, New York City, 1975. She has been in numerous group shows including "Woman Photographs Man," "Breadth of Vision," "In Celebration of Women" and *The Village Voice* Photo Contest Show at the International Center of Photography. Her photographs have appeared in 1969 *U.S. Camera World Annual, Pageant, Actors Equity* and *Inprint* magazines. (Plates 12, 109)

Connie Moberley (Houston, Texas) was born and raised in Texas, where she received a B.S. in photography from Sam Houston State University. Currently, she photographs for advertising, commercial, and industrial publications involving assignments across the United States, Canada, Mexico, and the Caribbean. (Color Plate 3)

Rhoda Mogul (East Norwich, N.Y.), a freelance photographer and extensive traveler, has exhibited her work in several group shows including "Breadth of Vision" and "Woman Photographs Man." (Plate 84)

Barbara Morgan (Scarsdale, N.Y.), though educated as a painter at UCLA,

turned to photography as early as 1935, when motherhood responsibilities made painting impossible. The publication of her first book, *Martha Graham: Sixteen Dances in Photographs*, in 1941 established her as one of the most brilliant photographers of her time, and her continued contributions to the field in exhibitions, lectures, seminars, and workshops has been most valuable. A monograph of her work was published in 1972, and most recently she was represented in *Life*'s "Remarkable American Women" at the International Center of Photography. Even now at age 77, her energy and works are most remarkable. (Plates 64, 76)

L. P. Mulcahy (Tarrytown, N.Y.) is a freelance photographer who studied at the Germaine School and Hunter College. Besides photographing for the Westchester Ballet Theatre, and New York State Department of Mental Hygiene, she had her first exhibit at the White Unicorn Gallery in Irvington, New York, 1975. (Plate 74)

Marjorie Neikrug (New York, N.Y.), is the owner and director of Neikrug Galleries in New York City. She has designed and organized fine arts exhibitions throughout the United States in museums and galleries, including "There is No Female Camera." For the past four years, she has instructed a course at New York University entitled "The Photographer's Eye." (Color Plate 7)

Janet Nelson (Croton-on-Hudson, N.Y.), was a magazine writer and editor until photographic studies with Ernst Haas, Phillippe Halsman, and Ralph Gibson combined visual talents with writing abilities. Her work has been published in several national magazines and most recently exhibited at the International Center of Photography. (Plates 42, 98)

Dianora Niccolini (New York, N.Y.), is an Italian-born freelance photographer who created and established photography departments at both Lenox Hill and St. Clare's Hospitals in New York. Founder of Women Photographers of New York, and a member of the Third Eye Gallery, Ms. Niccolini has exhibited her work in numerous group and one-woman shows, and published in *Aphra* and *The History of the Nude in Photography*. (Plates 60, 65)

Sheila O'Hara (Brooklyn, N.Y.), is a freelance photographer who has taught in the Floating Foundation of Photography program at Bedford Hills Correctional Facility. Her work has been exhibited at the Women's Interart Center in New York City and the Third Eye Gallery, of which she is a member. (Plate 93)

Suzanne Opton (New York, N.Y.) is a freelance photographer and teacher who has received grants from the National Endowment for the Arts, and the Vermont Council on the Arts for her work. She has shown in several group shows at the Neikrug F.I.T. and Midtown Y Galleries in New York, and the Portland Museum of Art in Portland, Maine. A portfolio of her photographs was published in the 1976 *Popular Photography Annual*, and her work has appeared in *Time, Esquire, Americana, The New York Times,* and *The Village Voice,* among others. (Plates 17, 31, 85, 88, 115)

Marcia A. Prager (State College, Pa.) is a Pratt graduate with an M.F.A. in photography who currently teaches at Pennsylvania State University. Her work has been exhibited in several group and one-woman shows, and was published in *Anthology: Young American Photography.* (Plate 97)

Joyce Ravid (New York, N.Y.) is a New York photographer whose work has appeared in *Vogue, Playboy, The Feminist Art Journal, Art News,* and other publications. (Plate 40)

Fran Riche (Ridgefield, Conn.), once a student of Paul Caponigro and Ken Heyman, now operates a portrait studio. She was grant recipient of a Connecticut Foundation for the Arts Grant in 1974, and her work has been exhibited at the Aldrich Museum, Boston Center for the Arts, and the Portland Museum, to name a few. (Plate 72)

Abby Robinson (New York, N.Y.) is a freelance photographer whose work was seen in the "Bus Show," "Breadth of Vision," and a one-woman exhibit at the Midtown Y Gallery. (Plate 41)

Trudy Rosen (New York, N.Y.) has had her work published in *Ultra* and *Viva* magazines, as well as on book jackets and record covers. She has produced a color videotape, "The Best Kept Secret," and a show, "Noontime Fantasies." A book of erotic photographs is her current project. (Plate 32)

Eva Rubinstein (New York, N.Y.) was born of Polish parents in Argentina, and lived in Paris until World War II. Trained in dance and theatre, she began photographing in 1968, and has since published and exhibited her work extensively both here and abroad. A monograph of her photographs in 1974 and a limited edition portfolio in 1975 are among her published credits. Ms. Rubinstein's work is in several public and private collections in the United States and Europe. (Plates 26, 28)

Nickola M. Sargent (New York, N.Y.), a graduate of Ohio State University, writes advertising copy for a publishing house, and photographs freelance with an eye for the narrative. Ms. Sargent studied photography with Dorothy Kehaya at the School of Visual Arts, and her work has been exhibited at Hanratty's Photo Gallery, the International Center of Photography, in "Breadth of Vision," and in "Woman Photographs Man." (Plate 83. Color Plate 1)

Robin Schwartz (New York, N.Y.) is a graduate of N.Y.U.'s School of Film and Television, and produced a feature-length videotape on women's sexuality. Her work appears in the book *Ecstasy,* on record albums for singer/composer Laura Nyro, and in numerous magazines. In 1973 she was sent to four South American countries to produce a slide show and photojournalistic report for WNYC's "Changing World of Women." (Color Plates 5, 6)

Suzanne Seed (Chicago, Illinois) has exhibited at New York's Neikrug Gallery and the Floating Foundation of Photography, as well as at Chicago's Center for Photographic Arts and The Darkroom. Her work is in the collections of the Chase Manhattan Bank of New York and the Exchange National Bank of Chicago, and her freelance clients include *Time, Life, Playboy, Mademoiselle,* CBS and NBC. Her book, *Saturday's Child* was first published in 1973, and she has three books in progress. (Plate 82)

Eva Seid (New York, N.Y.), a former Parson's student, received a 1976–1977 CAPS grant to continue her work of photographing ethnic groups in New York, and an Honorable Mention in the 1976 *Redbook* Photography Contest. Her photographs have been shown at the First Women's Bank and the Educational Alliance, and published in the *Gramercy Herald* and *Photo Reporter.* (Plate 47)

Beth Shepherd (New Canaan, Conn.) is assistant director of Photo Graphics Workshop in New Canaan, Connecticut, and instructor at the University of Bridgeport. Her work was represented in the exhibits "Women Look at Women," "Breadth of Vision," and "Images of Women," in the Slater Memorial Museum, and in a one-woman show at Rider College. (Plate 86)

M. K. Simqu (Philadelphia, Penn.) teaches photography at Drexel University in Philadelphia. Her work has been exhibited in many group and one-woman shows both in the United States and Europe, and is represented in the permanent collection of the Portland Museum of Art in Maine. (Plates 81, 87, 94)

Nina Howell Starr (New York, N.Y.), who began photographing at age fifty-eight, has since exhibited and published on numerous occasions. A one-woman show of her work, "Magic Lantern Series," was seen at the Photographers' Gallery in London last year, and recently she was represented in "Images of Woman" at the Portland Museum in Maine, and "Women's Art Symposium" at Indiana State University. (Plates 95, 108)

Erika Stone (New York, N.Y.) was once a student of Berenice Abbott at the New School for Social Research. Ms. Stone has enjoyed an active career as photojournalist and magazine photographer for some twenty-five years. Though her work has been published in *Time* and *Der Spiegel,* recent motherhood has made her a specialist in photographing children and family life, with a number of children's books in evidence. (Plates 34, 43)

Martha Swope, official company photographer for both New York City Ballet and American Ballet Theater, is well known for her photographic work in theater and dance. She is the author of several photography books about the dance, the latest being *Baryshnikov at*

Work, published in 1976. (Plate 11)
Sherry Suris (New York, N.Y.) is a self-taught photojournalist whose work appeared in Cornell Capa's exhibit and book, *Jerusalem: City of Mankind;* in a two-person show with Andre Kertesz in Ohio; and in several solo and group exhibits. Her photographs have been published in *Life, The New York Times Magazine, Time, Newsweek, Ms.* magazine; and are in the collection of the Exchange National Bank of Chicago, among others. Ms. Suris is represented in New York by the Witkin Gallery. (Plates 18, 69, 91)

Suzanne Szasz (New York, N.Y.) has been a successful magazine photographer since the 1950s for *Life, Look, Saturday Evening Post, Ladies' Home Journal, McCall's* and many other publications. She has initiated and produced several books, the most recent being *The Silent Miaow, Child Photography,* and *Wedding Photography.* A new one in collaboration with Dr. Benjamin Spock is in progress. (Plate 75)

Judith Turner (New York, N.Y.) is known for her architectural photography, namely her perceptive studies of the Cooper Union renovation. A graduate of Boston University, and a book jacket designer, Ms. Turner has had solo exhibitions at Princeton University, Phoenix Art Museum, Whitney Museum Art Resources, and the Cooper Union. (Plate 49)

Karen Tweedy-Holmes (New York, N.Y.) had her first one-woman show at New York's Exposure Gallery in 1970—a group of male nudes. Since then her concentration on portraits of people, animals and buildings has led to exhibits at Images Photographic Gallery in New Orleans, and the Carlton and Popular Photography Galleries in New York. A number of her New York City studies will appear in Helene Hanff's *Apple of My Eye.* (Plates 7, 8, 59, 62)

Bernis von zur Muehlen (Reston, Va.), a graduate in literature from the University of Pennsylvania, first expressed concern with images in poetic form. Since her transition to photography in 1973, she has exhibited her photographic images in several group and solo shows in the Washington area. Ms. von zur Muehlen's work received a purchase award from the Corcoran Gallery of Art and was published in *Lightwork, Communication Arts,* and *Potomac* magazines. (Plates 4, 61)

Alison Ehrlich Wachstein (West Orange, N.J.) freelances and teaches photography at Seton Hall University and at Fairleigh Dickinson University. She has worked as staff photographer on the *Aspen Times* in Colorado and for Worrall Publications in New Jersey. Her photographs have appeared in several periodicals and books, and a book about pregnancy and childbirth in the United States is her current project. (Plate 35)

Linda Szabo White (Ridgefield, Conn.) is a School of Visual Arts graduate whose recent photographs have been exhibited in the Addison Gallery, Massachusetts, Fashion Institute of Technology, New York City, and Portland Museum of Art in Maine. Her work has been purchased by the Museum of Modern Art, the Springfield Museum, and the Portland Museum. (Plates 103, 104, 105, 106)

Helena Chapellin Wilson (Chicago, Illinois) was an interior designer in Europe and her native Venezuela before coming to the United States in 1971 to pursue photographic studies. Since then, she has exhibited her photographs extensively both here and abroad, and has been published in the *Popular Photography Annual 1975* and the *Chicago Tribune Magazine.* Her work is in the collections of the Exchange National Bank of Chicago, and of the law firm of Friedman and Koven, Chicago. (Plate 1)

Dannielle B. Hayes, the editor, is a graduate of Cooper Union and works as a freelance photographer, illustrator, and journalist. Her photographs have been exhibited in several group shows including "From Many, One" at the Floating Foundation of Photography, 1976, and "Breadth of Vision: Portfolios of Women Photographers," and her work is represented in private collections in the United States and Canada. As photography chairwoman for the International Women's Arts Festival in 1976, she conceived and directed "Woman Photographs Man," the show from which this book was adapted. She lives in New York City with her husband, Merle Steir, a sculptor, and their daughter, Amie.

Molly Haskell, author of the Introduction, is the film critic for *The Village Voice* and contributes frequently to several other journals. She is the author of *From Reverence to Rape: The Treatment of Women in the Movies* and is presently at work on her second book. She is married to critic Andrew Sarris and lives in New York City.